ILLUSTRATED TALES OF
NORTHUMBERLAND

ROB KIRKUP

AMBERLEY

First published 2023

Amberley Publishing
The Hill, Stroud
Gloucestershire, GL5 4EP

www.amberley-books.com

British Library Cataloguing in Publication Data.
A catalogue record for this book is available from the British Library.

ISBN 978 1 4456 9884 7 (paperback)
ISBN 978 1 4456 9885 4 (ebook)

Origination by Amberley Publishing.
Printed in Great Britain.

Contents

Introduction

The beautiful county of Northumberland, situated on the English-Scottish border, has an incredible, rich history that lends itself perfectly to the subject of myths and legends. Northumberland has borne witness to countless horrendous, bloody events; from the Viking raid of the Holy Island of Lindisfarne in 793, the first Viking assault seen in the British Isles which marked the very beginning of the Viking age in Europe, to the Anglo-Scottish wars which raged from the early fourteenth century until the Union of the Crown in 1603. The most notable battle of this period was in 1513 at Flodden Field where 14,000 were killed in the space of just three hours, in the bloodiest battle ever in the history of England. Unsurprisingly, all this bloodshed and suffering has left a scar on England's most northern county.

Evidence of these less peaceful times peppers the Northumbrian landscape and is the primary reason that Northumberland has seventy castles, the most of any county in England. The wild and remote county is also the least populated in England, with only sixty-two people per square kilometre.

Throughout these pages you will read some of the better-known, and lesser-known, myths, legends, and folktales of one of England's most mysterious counties. Are these tales true, or simply works of fiction from a bygone age? I guess I will leave that for you to decide.

All photographs are by the author unless otherwise stated, and with reference to some of the older images included in the text, I would wish to state that despite prolonged and exhaustive enquiries, tracking down some copyright holders has not been possible.

Finally, while I have tried to ensure that the information in the text is factually correct, any errors or inaccuracies are mine alone.

The Hermit of Warkworth

The village of Warkworth is famous for its historic castle, which draws visitors to the area from all over the country. The castle dates back to 1140 and stands today as a magnificent ruin, visible for miles around, with its massive medieval keep with its tall central watchtower.

Warkworth is home to one of Northumberland's most tragic legends, but our tale does not involve the castle; it centers around a lesser-known, but by no means less impressive, location a little upstream.

A walk of around half a mile along the River Coquet, followed by a short ferryboat ride to the other side of the river, finds Warkworth Hermitage.

The hermitage is a very unusual building carved out of the limestone rock face in around 1489. It contains a chapel, dormitory, and a cell. The tiny chapel contains an effigy of a beautiful young woman, her hands raised in prayer. At her feet kneels a hermit, his hand pressed to his heart. This is Sir Betram of Bothal, the Hermit of Warkworth, and his beloved Isobel.

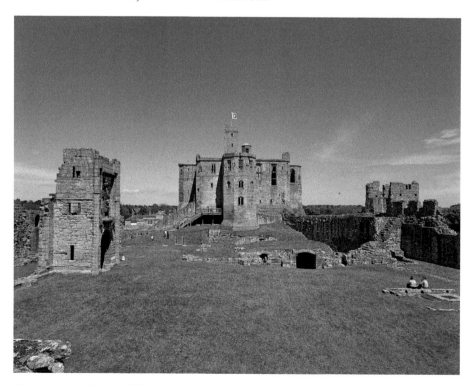

The impressive keep of Warkworth Castle.

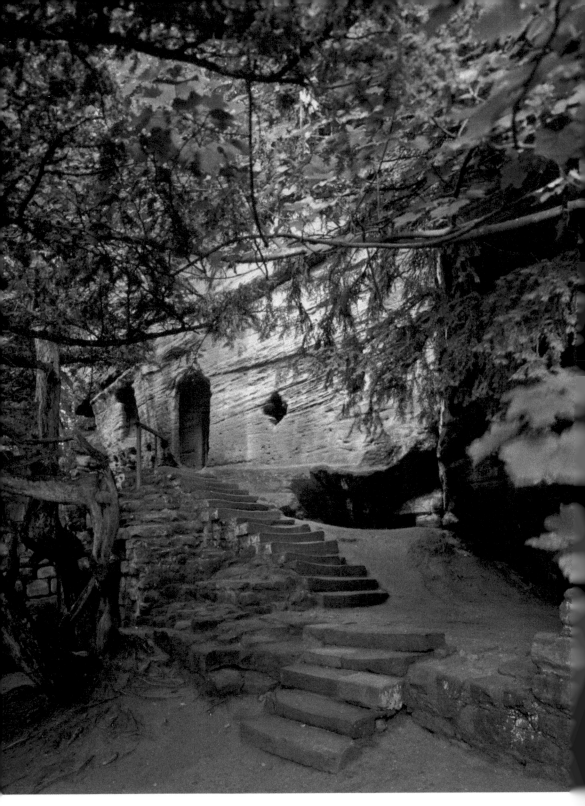

Warkworth Hermitage.

The story, first published in 1771 in the ballad 'The Hermit of Warkworth' by Bishop Thomas Percy, begins at a grand banquet held at Alnwick Castle. The Lord of Widdrington was present with his daughter Isobel. One of Earl Percy's knights, Sir Bertram of Bothal, was very much in love with Isobel, and she loved him equally. At the feast Sir Bertram promised Isobel that he would complete a feat of great courage and earn her hand in marriage.

Shortly afterwards, a border skirmish presented the perfect opportunity for Sir Bertram to fulfil his promise to Isobel. Buoyed by this thought, he fought with the power and courage of ten men, single-handedly killing a great number of Scots. However, he suffered a blow to the head in battle, which sent his helmet flying, and caused him injuries that would have killed a lesser man.

Sir Bertram was rushed to nearby Warkworth Castle, where his wounds were tended, and he could rest and recover. Word was sent to Isobel, and she set out immediately to join him. However, she never arrived. Unbeknown to Sir Bertram, she had been captured and imprisoned at a Scottish stronghold.

After a long recovery, Bertram set out to Isobel's home with his brother but was horrified to hear that she had set off weeks ago to Warkworth Castle. He knew immediately she must have been taken prisoner by the Scottish enemy and swore he would not rest until he had found and rescued her. Bertram's brother agreed to help, and the two of them decided to split up and make enquiries.

Over the weeks that followed he travelled hundreds of miles, searching far and wide for his true love. He was starting to lose hope, and then a chance conversation with a monk gave him a fresh lead. The monk told him that a Scottish lord was holding a pretty young girl captive at his castle. Pinning all of his hopes on this information, he raced to the castle. When he got near to the castle, he took shelter in a cave nearby with a good view of the castle entrance and waited. Sir Bertram knew that if he was to charge into the Scottish-occupied fortress, he would soon be killed, so his only option was to bide his time and hopefully see or hear something that would confirm that the girl being held here was his Isobel.

He watched and waited patiently for over three days. Then on the fourth night, his patience was rewarded. He saw a Scottish clansman arrive at the castle, and when he left shortly after he was with a familiar young woman, his Isobel. He wasted no time and raced over to the Scot, who was now helping Isobel onto his horse and with one slash of his sword he took the man's head clean off. Isobel screamed out in horror, which frightened the horse, who threw her off. Her head struck a rock, killing her instantly.

Sir Bertram was broken. He screamed to the heavens above him and then looked down at the woman he loved lying dead in a pool of blood. Next to her was the severed head of the Scottish clansman. However, it was a face he recognised. It was his own brother, who had been rescuing Isobel whilst in disguise.

He lay down on the ground with them as if dead himself; he was paralysed with grief.

The elaborate interior of the lovingly carved hermitage.

He eventually dragged himself onto the back of his horse and headed back to Warkworth Castle. He gave away all of his money, land, and anything he had of value to the poor. He then sought permission from Earl Percy to build himself a small home in which he could see out his days in solitude. He built the hermitage and spent the rest of his life alone, never speaking to anyone ever again. A servant from the castle brought food to the hermit every day, for many years, simply placing it down and leaving. On one particularly cold December morning, the boy found the frail hermit hunched before a small fire, which had almost gone out. The boy said he would go for some firewood, but as he was about to leave Bertram grabbed his hand and pulled him close. He seemed to be trying to say something but Bertram had not said a single word in over twenty years. 'Isobel' he finally said and with that he died in the boy's arms.

The inscription Sir Bertram carved above the entrance to the hermitage is a lasting reminder of the guilt and sadness that tortured him daily. Translated it reads 'My tears have been my meat night and day'.

Location: NE65 0UJ

A print of the hermitage dating from 1814.

Lord Derwentwater's Lights

Dilston Castle was built by Sir William Caxton on the site of an earlier pele tower belonging to the Divelston family, with work starting in 1417. The end result was a grand three-storey tower house.

In the early seventeenth century, the Dilston heiress married Edward Radcliffe, and Edward had a private chapel built adjoining the tower in 1616. The chapel was built so that the devout Roman Catholic Radcliffe family could worship their God in secret, as it was against the law to do so. The chapel was built with money originally raised to finance the Gunpowder Plot, and Guy Fawkes is believed to have spent some time at Dilston a decade earlier, shortly before his death. The Radcliffe family made many improvements over the next century, including the building of a new manor house that incorporated the original tower. In 1709, development began to replace the manor house with a large mansion. However, the mansion was never completed due to the property being seized by the Crown in 1716. The events leading up to the castle being taken from the Radcliffe family introduces us to the castle's most famous former resident, James Radcliffe, the last Earl of Derwentwater, although some believe his ghost still roams the castle to this day.

Dilston Castle.

Dilston Chapel.

James Radcliffe was a quiet young man. He lived at Dilston Castle with his wife, Anna Maria, and their infant child. These were troubled times, with constant wars and revolts, but the earl was content with his life and managed to steer clear of trouble. However, during the Jacobite Rising his wife encouraged him to become involved with a conspiracy to reinstate a Scottish king, a Stuart, to the throne. He was a peace-loving man and had no intention of going to war, but she persisted until the earl relented and took up arms. He rounded up a large troop of local men and headed off to war. Things did not go as planned: the rebellion folded, James surrendered, and on 10 January 1716, he was sentenced to death aged only twenty-six.

On the evening of 24 February 1716, as James was beheaded at Tower Hill, the rivers on the estate of Dilston Castle ran blood red, and the Aurora Borealis shone brilliantly in the night's sky over the region, brighter than it had ever been seen before. This was taken as a sign and the Northern Lights, in Northumberland, would be forever known as Lord Derwentwater's Lights, and with this, the dramatic and tragic events of the earl's short life were soon firmly entrenched in Northumbrian folklore.

His body was discreetly returned north to be buried at Dilston. However, his heart was taken to a convent in Paris where the prioress, Anne Throckmorton, witnessed it being enclosed within the chapel's walls.

Another legend has it that the morning following the execution, there was a terrible thunderstorm, and the River Derwent was said to have hundreds of adders swimming in it. This had never been seen before, or since, but the locals believed each of the snakes represented the spirit of one of James Radcliffe's fallen men.

Location: NE45 5RJ

The River Derwent ran blood red following James Radcliffe's execution.

The fast-running River Derwent.

The Alnwick Bloodsucker

Alnwick is Northumberland's county town and is unquestionably one of the prettiest towns in all of England. In fact, Alnwick has come out on top of *Country Life* magazine's 'best place to live in Britain' annual feature on multiple occasions. Alnwick is a town steeped in history, and it shows as you explore the narrow, medieval back streets, the cobbled roads, and the huge fifteenth-century tower gate which gives entrance to the main street.

Alnwick is best known for its magnificent castle, which dates back to 1096. It was the seat of the Percy family, the original dynastic power in the north, and is now home to the Duke of Northumberland. It is without a doubt the most impressive medieval castle in northern England, and the second largest inhabited castle in the country, behind Windsor Castle. Visitor numbers to the castle have understandably soared since the turn of the twenty-first century when it was chosen to portray Hogwarts School of Witchcraft and Wizardry in the Harry Potter films.

Despite the idyllic setting in the tranquil of the Northumbrian countryside, Alnwick is not without its own dark legend, for Alnwick once was home to its very own vampire.

This 'tale' was first recorded by William of Newburgh Priory in the twelfth century, in his *Historia Rerum Anglicarum,* a chronicle of English history from 1066 until 1198, the year of his death. This work actually predates the existence of the word 'vampire' by over 500 years, instead the creature being referred to by the Latin word *sanguisua* meaning 'bloodsucker'.

Legend has it that a Yorkshire man, who had lived a dishonest life and wishing to distance himself from both his enemies and the law, headed north and found himself in Alnwick, where he secured himself a job serving the lord of the castle.

The fifteenth-century Bondgate Tower was the main gate into medieval Alnwick.

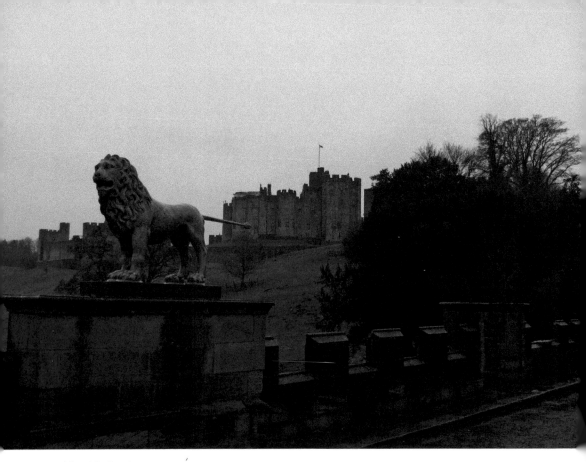

Alnwick Castle.

Alnwick's First World War memorial.

He wed a local girl, but he suspected her of having an affair. So, he laid a trap to find out for himself if it was true. He told her that he was going on a journey that would take him away for several days. He returned to the castle after dark and hid on a beam in the chamber he shared with his wife, overlooking their marriage bed.

Unfortunately, he was proven right when a young man from the town climbed into bed alongside her. Seeing his wife in the throes of passion with another man caused him to lose concentration and he fell from the beam, landing heavily on the ground next to where they were laying.

The man fled, but his wife helped her husband to his feet, acting as if nothing had happened. When he came to conscience, he demanded her to explain her adultery and threatened punishment. However, she retorted 'Explain yourself, my lord' and told him that he was talking nonsense, which was attributed to a sickness that had caused him to act so irrationally, accuse her of something that he'd simply imagined, and ultimately fall. She called for the local priest, demanding her husband confess his sins and receive the Christian Eucharist, so he would no longer have such wicked thoughts. He refused.

Shaken by the fall and the sight of his wife in the arms of another man, he retired to bed to rest so he could deal with the situation the following day. However, for him, the following day would never come as he died that very night.

He was laid to rest with a Christian burial, but the man's corpse was far from at rest. For in the nights that followed, he was actually seen walking around the town causing a foul stench wherever we went. He would attack anyone who should have the misfortune to cross his path, and dogs throughout the town would howl all night long, many believed them to be under the dead man's spell. Livestock would be found dead nightly, appearing to have been torn apart by some kind of beast.

In the weeks that followed every house in Alnwick was filled with disease and death, as a plague spread through the town, and there was no doubt as to the cause: it was the man rising from his grave every night.

Before long the town of Alnwick, which had once been heavily populated, was almost like a ghost town as almost all of those who had escaped death had gathered their belongings and fled.

On the first Palm Sunday following the death of the man, and the reign of terror that had followed, two brothers who had lost their father to the plague decided to take action and rid Alnwick of this monster once and for all. Knowing the priest was busy hosting a feast at his vicarage; they headed to the cemetery, each clutching a spade and found the grave of the dead man. They expected to have to dig deep into the ground, but the soil had recently been disturbed and it did not take them long to find the coffin. Opening the lid, the man didn't look like he had been there for months – he had not even began to decay, and he had blood all around his mouth. One of the brothers struck the body with his spade with great force, and as the blade pierced his flesh, blood spurted out in all directions.

The cobbled streets where the Alnwick Bloodsucker prowled.

The brothers lifted the carcass from the grave and dragged it outside of the town boundary, where they constructed a funeral pyre to burn this monster once and for all. However, one brother said that the body would not burn unless the wicked heart was removed.

They both started striking the body repeatedly with savage blows from their spades, and one reached inside the mangled body and pulled out the heart, throwing it into the fire. This was followed by the body that crackled and hissed as the flamed consumed it. By now, some of the villagers had came to see what was going on, horrified by what greeted them. The brothers calmed the small crowd, explaining that this is the only way to rid the town of the curse that had beset it.

It appeared the brothers were right, as from that day as the nightly horrors stopped, the stench that had hung over the town faded, and life returned to normal.

The Alnwick Bloodsucker is not the only worthwhile tale associated with the town, as there is a pub on Narrowgate called The Dirty Bottles. The building dates from the seventeenth century, and in the eighteenth century, the innkeeper died suddenly while placing bottles in the window of the inn. His widow claimed that whoever attempted to remove the bottles would be cursed and would too die. The bottles have never been touched since and remain to this day sealed between two window panes, undisturbed and covered in over 200 year's worth of dust and cobwebs.

Location: NE66 1NQ (Alnwick Castle), NE66 1JG (The Dirty Bottles)

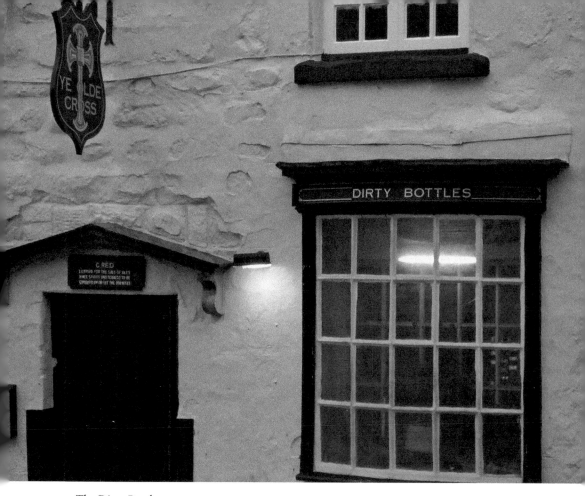

The Dirty Bottles.

The Hedley Kow

'The Hedley Kow' (often pronounced 'koo') is a shapeshifter trickster said to roam the village of Hedley on the Hill. It is believed that the tale was first committed to print in 1894 by Joseph Jacobs in *More English Fairy Tales*.

The Hedley Kow is described as a bogle. A 'bogle' (sometimes called a bogill or boggle) is an old Northumbrian name for all manner of folklore creatures believed to go about the county spreading mischief. The Hedley Kow is said to be completely harmless, and his appearance was never frightening; his encounters would always end with a loud laugh at the expense of the human he had just gotten one over.

Hedley on the Hill.

The village pub – the Feathers Inn.

The tale Jacobs wrote of involved a poor, elderly lady living in Hedley on the Hill who made a living running errands for the people of the village. She didn't make much money, but with favours such as a meal at one house, some meat from another, she made ends meet, and was never seen without a smile on her face.

One glorious summer's evening she was heading home after a hard day of helping the locals, when she happened upon a large black pot at the side of the road. She stopped to look at it and looked around seeing that she was the only person there, so the owner was nowhere to be seen. 'Now that would be the very thing for me, if I had anything to put into it'.

While wondering why it has been left, and considering that maybe it had a hole in the bottom of it, she bent down and took the lid off, and what she saw took her breath away. It was filled to the brim with glistening gold coins. 'Mercy me! it is fit brim full o' gold pieces!'

She couldn't get over her incredible good fortune and stood and starred at the pot. She was rich. However, how on earth would she get it home?

She fastened one end of her shawl to the pot and dragged it down the road behind her. As she walked she talked aloud to herself, plotting what she would do with her new found riches. 'It'll certainly be soon dark, and folk'll not see what I'm bringing home with me, and so I'll have all the night to myself to think what I'll do with it. I could buy a grand house and all, and live like the Queen herself, and not do a stroke of work all day, but just sit by the fire with a cup of tea; or maybe I'll give it to the priest to keep for me, and get a piece as I'm wanting; or maybe I'll just bury it in a hole at the foot of the garden. Ah! I feel so grand, I don't know myself rightly!'

The warm summer night combined with the vast weight of the pot of gold soon meant that the old lady was in need of a rest. She stopped and turned to look once more at her new found treasure, but when she looked it was no longer a black pot at all, but an enormous lump of silver.

Some of the beautiful cottages in the village.

She stared at it, completely dumbfounded. She looked all around for the pot, but convinced herself it must never have been a pot of gold to begin with. 'I'd have sworn it was a pot of gold, but I reckon I must have been dreaming. Ay, now, that's a change for the better; it'll be far less trouble to look after, and none so easy stolen; yon gold pieces would have been a sight of bother to keep 'em safe. Ay, I'm well quit of them; and with my bonny lump I'm as rich as rich.'

After her short rest she headed for home once more, even happier with her huge lump of silver than she was with the gold, and she continued to plan what she would spend her money on. Before long though, she needed to rest once again. Once again she looked at her silver, only to see what that it was now a great big lump of iron.

'Oh, my!' said she, 'now it's a lump o' iron! Well, that beats all; and it's just real convenient! I can sell it as easy as easy, and get a lot o' penny pieces for it. Ay, hinny, an' it's much handier than a lot o' yer gold and silver as 'd have kept me from sleeping o' nights thinking the neighbours were robbing me.'

She couldn't believe her luck, and chuckled to herself as she once more headed home. She took another look over her shoulder and stopped when she saw that once more it had changed. It was now a large stone. Seeing this she was over the moon, it was exactly what she had needed to hold her door open.

She headed home, imaging just how the stone would look propping open her door over what remained of the summer.

She reached her garden gate and bent over to remove her shawl from the stone. All of a sudden the stone seemed to move, she backed away, and the stone jumped up, and grew into a huge horse with four long legs, a long tail, and a flowing mane. She stood and stared as the horse raced off into the night, laughing all the way.

The old woman watched it in the moonlight until it vanished from sight.

'WELL!' she said at last, 'I do be the luckiest body hereabouts! Fancy me seeing the Hedley Kow all to myself, and making so free with it too! I can tell you, I do feel that GRAND'.

With that she went inside her cottage to contemplate over a cup of tea just how lucky she truly had been that night.

Location: throughout the village

The elderly lady in the story was pretty lucky after all, when you consider the view from Hedley on the Hill.

Sir Guy the Seeker

The spectacular sea-beaten ruin of Dunstanburgh Castle is set against a rugged seascape in the heart of Northumberland. Its remote location makes it one of the most dramatic sights in the county, and on clear autumn days, photographers flock from all over the region to capture Dunstanburgh Castle, framed by magnificent sunrises, sunsets, and, on clear nights, the Northern Lights.

Thomas, Earl of Lancaster, ordered that the castle be built on an isolated rocky site in 1313. However, the earl never got to see the finished castle, as he was executed in 1322, three years before the building was complete, for his revolt, and defeat, at the Battle of Boroughbridge. The end result was the largest castle in Northumberland, almost 11 acres in size and protected on one side by the unpredictable North Sea and the other by a ragged cliff face.

King Edward II took over the castle upon Thomas' death, but ownership changed hands countless times in the years that followed, and by the time of the War of the Roses, the castle was besieged by Yorkists, whilst under the control of the Earls of Lancaster. The castle suffered considerable damage, and when

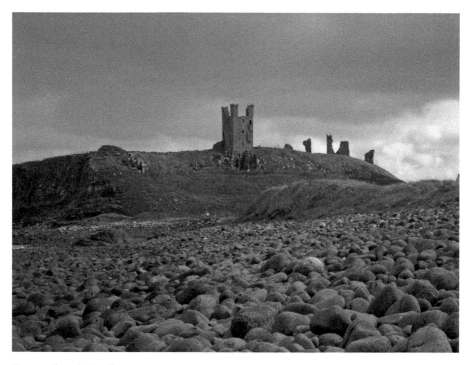

Dunstanburgh Castle.

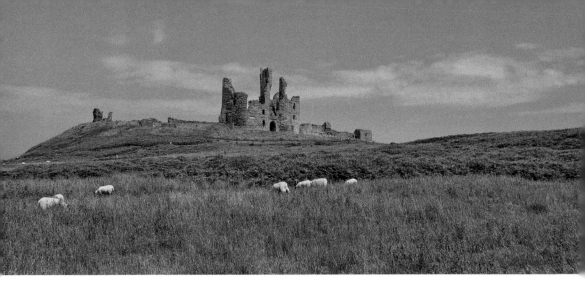

The castle dominates the landscape for miles around.

the war ended in 1487, the castle was abandoned and left to decay. Fortunately, thanks to the remote location, and the work of English Heritage, the castle stands today as an imposing and formidable ruin.

With a walk of over 1 mile from the nearest car parking in Craster, itself famed far and wide for the Craster kippers, it's always a special experience walking the well-trodden grass track towards the castle, catching the first glimpses of the ruined gatehouse as the raging North Sea crashes only a metre or so to your right.

Like every good castle, especially a ruin in such a remote, windswept location, it wouldn't be complete without a plethora of fantastical tales associated with it, and Dunstanburgh doesn't disappoint. There are said to be a number of ghosts that call the ancient castle home, and there has long been talk of secret passageways running from beneath the castle, connecting it to buildings of nearby villages, and even to caves along the coastline. However, by far Dunstanburgh Castle's most famous story is the legendary tale of the knight Sir Guy the Seeker.

First published in verse by Matthew Lewis, as part of his Romantic Tales, in 1808, the tale of Sir Guy the Seeker sees the brave knight happen upon Dunstanburgh Castle on a dark night, during a torrential storm when the flash of lightning revealed the ruined towers to him.

He tried to find a way into the castle, but the gates were locked tight, so he sought refuge from the weather in an entranceway next to a single yew tree, awaiting a break in the weather. As he stood, propped on his lance, he listened to the never-ending downpour, when off in the distance he heard the toll of a bell chiming the late hour. On the final toll, which signalled midnight, a bolt of lightning whizzed past his head and struck the gates of the castle, bursting them open.

From the darkness, an old man emerged. He was gigantic, with a long white beard. He had a bald head covered in flames, he wore a wondrous robe, tied closed by a metal chain aflame with fire licking around the white hot metal, wrapped three times around his waist.

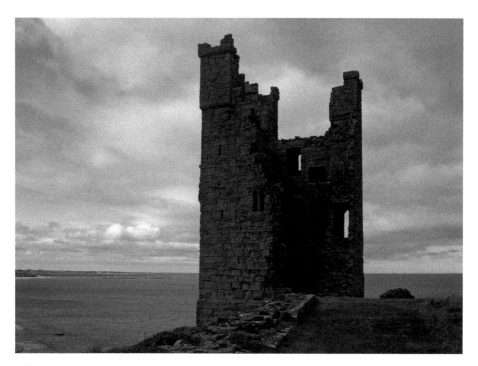

Lilburn Tower.

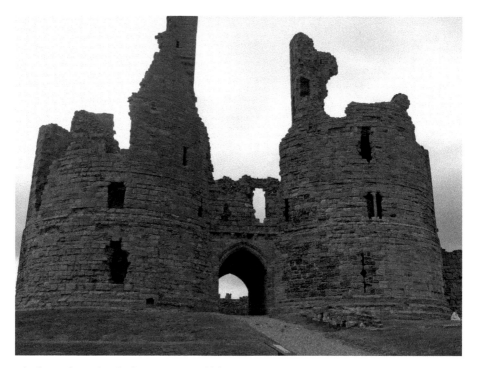

The keep through which Sir Guy would have entered.

The figure introduced himself as warlock, and then told Sir Guy of a princess in dire need of help.

'Sir Knight, Sir Knight, if your heart be right, and your nerves be firm and true. Sir Knight, Sir Knight, a beauty bright in durance waits for you.'

He led the way, and brave Sir Guy didn't hesitate to follow, as if a maiden required his rescue, it was his duty as a knight to save her from peril. He followed the giant figure, reaching another gate, which was locked with a living snake as its bolt. The snake eyed up Sir Guy, venom dripping from his hissing mouth, burning the floor where it landed below. The snake readied itself to attack the knight, when the warlock extended his wand striking the snake and it fell to the ground dead.

They rushed through the gate into the castle courtyard. The castle had appeared unoccupied but this was far from the truth; before Sir Guy stood over one hundred skeletal horses, and lying fast asleep throughout the courtyard were

The castle courtyard.

over one hundred armour-clad warriors, skeletal knights raised by an evil spell from all of the local graveyards to guard the princess. There was a crystal tomb between him and this army from Hell, and in the tomb, he could see the terrified princess, the most beautiful woman he had ever seen. Guarding over this tomb were two huge skeletons, each one easily over 9 feet tall. One held an enormous magical sword that had fallen from Heaven, and the other held a horn that the warlock claimed was the horn of Merlin.

'The maid's fate depends on you,' the warlock declared. 'Which should you choose to awaken her from her slumber, horn or sword?'

Guy wanted to take the sword and cut down every single one of these damned knights, but felt that he alone could not defeat them, so he went against his instincts and chose the horn. The moment he took the horn, the skeletal warriors awoke, stood up in union, and as one screamed their defiance to the skies above, then charged towards him, swords and axes at the ready. Sir Guy put the horn to his lips and blew.

As the army of the dead charged at Sir Guy, the warlock's voice rose above the battle cries 'shame on the coward who sounded a horn, when he might have unsheathed a sword'. As the swords struck him he was surrounded by a blue vapour from the warlock, and he lost consciousness.

He awoke the next morning in the entranceway outside the castle. There was no sign of the storm that had raged the night before, and his faithful horse was still tied to the yew tree next to him. Sir Guy thought that it had all been a dream until he realised he was still holding the horn. Remembering the terrified face of the princess, imprisoned in her crystal tomb, he raced back the castle gates, but they were locked tight once more.

From that day forth, it is said that Sir Guy became obsessed, unable to let go of his quest to save the princess, and he was unable to leave Dunstanburgh until he could find her and save her. He searched in vain for many years until his death and he was buried in a nearby churchyard. However, it is said that even in death, the ghost of Sir Guy has not given up and still seeks a way into the castle.

Despite this, most likely, being nothing more than a legend borne of Matthew Lewis' early nineteenth-century poem, visitors to the castle occasionally report, to this very day, catching a glimpse of a man appeared to be wearing a suit of armour, glinting in the sunlight, holding a horn and appearing to be frantically searching for something, or someone.

Location: NE66 3TT

The Devil's Causeway

The Devil's Causeway is a Roman road that stretches north through Northumberland from Corbridge to Berwick-upon-Tweed. Today some of the route is road, and some is bridleway.

The exact date the road was constructed is not known, but it's believed that it predates Hadrian's Wall, which was built from AD 122.

The road begins just north of Corbridge at a place called Portgate. Less than a mile to the east of this starting point was the Roman fort of Hunnum (also known as Onnum, and has been given the modern name of the Halton Chesters). Hunnum will have been built later, as it was the fifth fort on Hadrian's Wall, east to west, after Segedunum (Wallsend), Pons Aelius (Newcastle), Condercum and Vindobala.

Hunnum was a square fort over an area of around 4 acres. A stone on the west gate of the fort reads 'LEG VI V P F FEC', 'The Victorious Sixth Legion, Loyal and Faithful'. This made historians believe that the fort would have been initially garrisoned by a *cohors quingenaria equitata*, which is a unit containing 500 men, with half of them mounted. By the third century, it held a regiment of cavalry. It is very probable, given the proximity to the Roman road, that the Devil's Causeway was patrolled by a unit based there.

The Portgate lies beneath the ground between the Errington Coffee House and the roundabout.

The gateway to Halton Castle is located where the fort of Hunnum would have stood.

From this starting point the Roman road snakes north 55 miles, initially passing Hartburn and then Netherwitton, where a medieval tower once stood called Devil's Causeway Tower. Little is known of the tower, with records describing it as an irregular shaped tower, 15 metres long and 8 metres wide. By the nineteenth century, all that was still visible of the tower were the foundations, but ploughing of the land has since seen all traces of the tower completely erased from the landscape.

From Netherwitton the road passes Longhorsley, where in early 2002, a hoard of seventy Roman coins were found by a group of metal detector enthusiasts on a farm, close to the Devil's Causeway. The coins, which are now on display at the University of Newcastle, date from the reign of the Emperors Vespasian to Marcus Aurelius (AD 69–180).

The route continues in a north-easterly direction passing over the River Coquet, then joins the A697 just north of Longframlington, then leaves it and passes near Edlingham Castle. Continuing north it crosses back over the A697 and passes Powburn.

Half a mile from Powburn is further evidence of Roman occupation, as Crawley Tower, a pele tower that was built with reclaimed stone from the Roman camp of Aluana Amnis, stood previously on the site.

From Powburn the road joins the A697 again, crosses the River Breamish and follows the route of the river for 2 miles. Eventually the road, after passing Horton and Lowick, reaches the mouth of the River Tweed, at which point the Roman road comes to an end, where it would have supported a port.

Legends say that the Devil's Causeway was built by a race of giants called the Yotuns.

The biggest mystery surrounding the ancient road is how the Devil's Causeway got its name, and the truth is that no one knows – the origins of this name are lost to time.

Location: throughout Northumberland

The route of the Devil's Causeway near Horton.

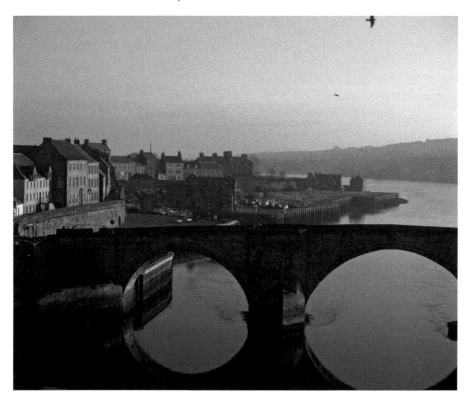

The port at Berwick-upon-Tweed where the Roman road ends.

The Redcap

The Redcaps are a race of goblin-type creatures native to the folklore of Northumberland and the Scottish Borders. Unlike some of the mischievous, and occasionally even helpful, creatures that call Northumberland home, you should hope you never have the misfortune to encounter a Redcap. These short, stocky creatures look like old men, but possess superhuman strength and speed. They have long, sharp pointed teeth, glowing red eyes, long fingers with nails as sharp as an eagle's talon, and long, dirty, shoulder-length hair. They wear heavy iron boots, carry a pikestaff, taller than they are, in their left hand, and have a blood-red cap on their head, from which they take their name.

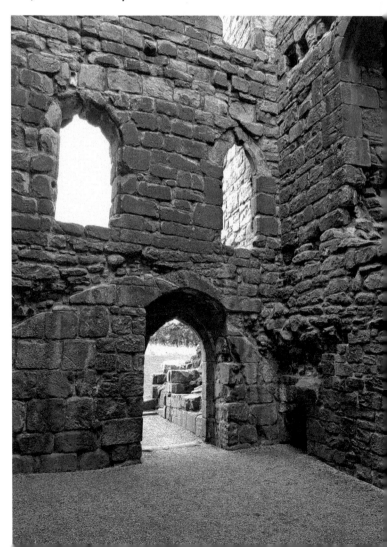

Etal Castle.

Unlike many other creatures of legend, the Redcap isn't solely tied to any one location, instead they are said to be attracted to the ruined castles and hill forts across the county, and inhabit the lowest reaches of these ancient monuments. For unknown reasons, they are especially drawn to those which have seen more than their fair share of bloodshed, death and suffering. The Redcaps lie in wait for lone visitors to enter their home and then use their incredible strength to throw enormous rocks at them. If one of these rocks find their target and they succeed in killing the innocent victim, then the Redcap will soak his cap in the fresh blood of the recently deceased, to preserve its crimson colour, as legend says that this enables the Redcap to live forever, but if the cap was to ever dry out the Redcap would die.

Redcaps, much the same as legendary creatures the world over, are known by many other names; in Northumberland, they have also been called Redcomb, or Bloody Cap (for obvious reasons). Dunters are also written about in Northumberland, and Powrie in the Scottish Borders, and these are often mistakenly considered to be another name for the murderous Redcap. However, nineteenth-century folklorist William Henderson wrote of the Dunters and Powrie as being a different species altogether in his 1866 book *Folklore of the Northern Counties of England and the Borders*, no less bloodthirsty, but with a completely different method for killing their human victims. Anyone unlucky enough to enter their lair would hear a sound like 'beating flax or bruising barley in the hollow of a stone', and this dreaded sound was the omen that death or misfortune would soon befall them.

The darkest depths of Norham Castle.

Chillingham Castle.

Henderson also speculated that Redcaps, and the various iterations of them, reside in these ruined ancient monuments because they are the vengeful spirits of men and women sacrificed so their blood could be used to bathe the foundation stone, intended to bring good fortune to the building.

There are only two ways to kill a Redcap: to either brand a crucifix, or to read aloud words from the holy bible. Either will cause the Redcap to scream in horror, before exploding into flames and disappearing. The only evidence that he was ever there will be one large, single tooth left in his place.

The most famous Redcap story doesn't relate to Northumberland, but to Heritage Castle in Newcastleton, just north of the border, and the nightmarish border noble William II de Soules, who was said to possess a Redcap as a familiar. De Soulis was a wizard and a practitioner of the dark arts, and his familiar, known as Robin Redcap, was much feared by the people of the area. De Soules and Robin Redcap reigned terror over the terrified locals, until they eventually rose up to overthrow him. Rendered immune to weapons and even hanging, de Soules was eventually dragged to the nearby stone circle of Ninestane Rig, a stone circle in the Scottish Borders, where he was boiled alive in molten lead.

Robin Redcap is said to remain at Hermitage Castle to this day, loyally continuing his long-dead master's malice.

Left: Warkworth Castle.

Below: An early nineteenth-century illustration of Hermitage Castle.

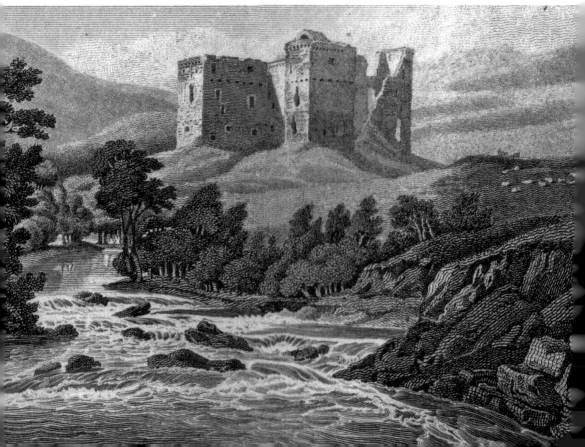

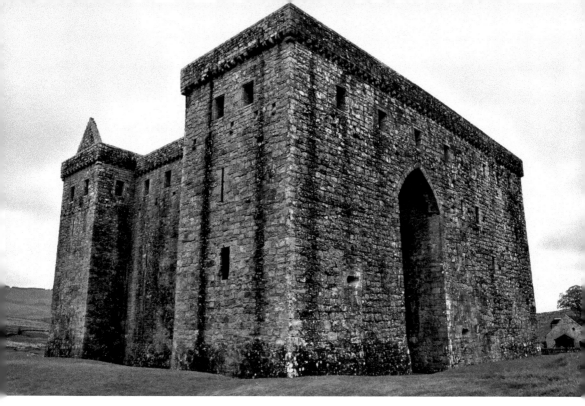

Hermitage Castle.

William de Soulis, in reality, was imprisoned, and died, in Dumbarton Castle for his part in the conspiracy against Robert the Bruce in 1320.

Similar in name but at completely the other end of the scale when it comes to murder and villainy are the Bluecap. Much the same as the Redcap, they are most often associated with Northumberland and the Scottish Borders, but they are mine spirits. They would inhabit mines and would appear as a bright blue flame. They would help miners with their work, alerting them to mineral deposits and warning them of potential cave-ins. Miners would report mine carts full to the brim with coal moving all on their own with a flicking blue flame hovering above. Bluecaps worked hard in the mines alongside the miners, and as a result, they expected payment for their work. Their payment was left in a corner of the mine, and the Bluecap would take no more or less than he was owed.

Location: At any historic ruin in Northumberland, so beware.

King Arthur of Northumbria?

Arthur, King of the Britons, a name known the world over from legendary tales, television shows, and Hollywood movies, which all tell of his heroic feats, fighting shoulder to shoulder with his Knights of the Round Table. The first mention of King Arthur was in a Latin historical compilation from AD 830 called *Historical Brittonum* ('History of the Britons'), and this details twelve battles in which Arthur fought, writing about him as a genuine historical figure. Ever since tales of brave King Arthur have been written about, growing, and evolving, and being romanticised with each new iteration of the stories.

As long as there have been tales of King Arthur, there has been debate as to whether he ever actually existed; whether he was a real man who led the defence of Britain against Saxon invaders in the fifth and sixth century, or whether he, and his fantastical battles and quests, are simply a work of fiction. There are

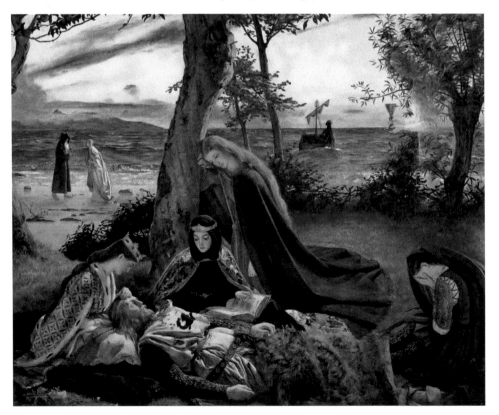

The Death of King Arthur by James Archer (1860).

historians in both camps, and evidence on either side, but the truth is that we simply will never know.

Something else that is hotly debated, and that is also destined to forever remain a mystery, is the answer to this question: if King Arthur did exist, where in Britain did he live?

King Arthur is most commonly linked to Caerleon in South Wales, Tintagel Castle in Cornwall, and Cadbury Castle and/or Glastonbury Tor, both in Somerset. With all of these sites being so far south of Northumberland, it begs the question: why are there so many places and legends in the county tied to Arthurian legend, and could King Arthur actually have been here, in Northumberland?

The best known tale of Arthur in Northumberland is found at Sewingshield Crags, situated in the shadow of Hadrian's Wall, where a castle once stood on the site. Sewingshield Castle was constructed in the fourteenth century and built from stone reclaimed from the Roman wall that would have stood in the time of King Arthur, running east to west across the country to, in the words of Emperor Hadrian, 'separate Romans from the barbarians' as south of the wall was Roman-occupied territory, and north of the wall, what we know as Scotland today, wasn't. By 1541 the castle had been abandoned and was a ruin, and is recorded in a survey from the year as 'At Sewyngeshealles is an old towre of thinherytaunce of John Heron of Chypchase esquier in great decaye in the rooffe & flores & lyeth waste & unplenyshed.'

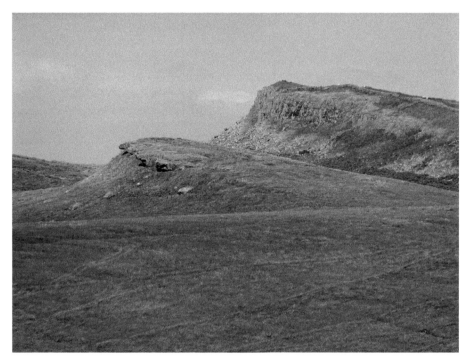

Sewingshield Crags.

By the nineteenth century little stood of the castle and the ground was levelled. However, Sewingshield hasn't been forgotten, as it has entered into legend for a miraculous encounter that took place during the years of the castle's decline.

A shepherd was knitting in the sunshine one day, sitting amongst the ruins of Sewingshield Castle, when his ball of wool rolled off and disappeared down a gap between the stones. He followed the wool and realised the gap was big enough for him to get into, so he descended into the darkness to retrieve his wool. He couldn't see the wool anywhere, so continued down a staircase, but he was losing the daylight, shining through the gap, the further he climbed down. Just as he was about to give up he realised he had reached the bottom of the staircase, and he was outside of a doorway to a room in the bowels of the ruined castle.

He entered and was taken aback to see the room was lit by a fire of pure white flame, and as he looked around the room he couldn't believe what he saw. The room was dominated by a huge round table, around which were seated King Arthur, Lady Guinevere, and all of Arthur's loyal knights. Two dozen hounds lay around the feet of their master. They were all fast asleep.

Upon the table were a bugle, a garter, and a sword, which some versions of the legend say was the sword Excalibur. The shepherd knew in an instant what he had stumbled across. There had long been a story told in the area that when the history books wrote that Arthur was mortally wounded by Mordred at Camlan, he didn't actually succumb to the wound, and instead he rested with his Queen, and his Knights of the Round Table, and could be awoken to fight once more again for his country if the garter was cut with the sword, and then the bugle blown.

He nervously approached the table. He picked up the sword and cut the garter. As the man reached for the bugle, the eyes of the figures around the table opened and the hounds stirred. The man was so startled that he left the bugle and ran from the room and raced back up the staircase. As he neared the surface he heard Arthur's voice cry out behind him.

> O, woe betide that evil day
> On which this witless wight was born,
> Who drew the sword the garter cut
> But never blew the bugle horn.

The shepherd forever regretted fleeing, but try as he might, day in, day out, searching for the entrance to the passageway, he could never find it again. King Arthur and his Knights of the Round Table remain in their eternal slumber to this very day beneath the Northumbrian countryside, just waiting to be discovered once again.

There are similar tales from around Britain, so there's every chance it's just a story passed down through the ages. However, it's interesting to note that there are a number of locations near to the area of our tale that are named for King

Arthur. Whether the names of these locations predate the tale, or if they were named after it came to prominence, is unknown.

Broomlee Lough is a glacial lake, almost 30 acres in size, dating from the last ice age 12,000 years ago. It is situated just to the north of Hadrian's Wall, next to Sewingshield Crags. The lake has long been linked with stories of a treasure dropped into the lake by a Dane called Oswald, who cast a spell upon it preventing anyone from retrieving it unless a chain made by a seventh generation blacksmith is used, pulled by a team of twin horses, twin oxen, and twin boys. Interestingly at the beginning of the century, the National Trust bought land around the lake, which came with a contractual stipulation that the new owner must continue to look for Oswald's treasure.

There is also an Arthurian story surrounding the lake: it has been written that when the wounded Arthur was brought to Sewingshield Castle, his legendary sword Excalibur was thrown into Broomlee Lough, where it was returned to the Lady of the Lake. Some believe that it remains at the bottom of the lake to this very day.

A mile north-west of Sewingshield Crags is the King's and Queen's Crag, two enormous sandstone rocks. These are believed to be named for Arthur and Guinevere, and a local legend says that King Arthur was sat upon one of the rocks talking to his Queen who was sat atop the other. She was arranging her hair and hadn't heard what he had said. Part offended, and partially to get her attention,

Broomlee Lough from Sewingshield Crags.

Queen's Crag.

he picked up a rock and threw it at her (a more than impressive distance of about a quarter of a mile). However, she saw it coming and caught it with her comb, deflecting it away, and it landed between the two of them. This stone remains to this day and can be recognised by the fact it has comb marks on top of it. This stone is just one of the many giveaways that this tale is almost certainly nothing more than a story, considering this stone weighs in excess of 20 tons.

Over on the Northumbrian coastline, Bamburgh Castle is one of the county's best known, and most visited, landmarks. What isn't well known about the castle, however, is that it too has ties to King Arthur. Back in the fifteenth century, Thomas Malory wrote *Le Morte d'Arthur*, which is now arguably the best known writing on King Arthur, as he pulled on all of the writing that had came before in French and English literature, and wrote the complete story of Arthur from his birth through to his death. One aspect Malory wrote of was the castle of Sir Lancelot, which comes into his possession after he single-handedly captures it during the task of proving himself worthy of a knighthood to King Arthur. Malory claimed that Bamburgh Castle was in fact Joyous Gard.

Bamburgh Castle dates back to *c.* 1120, so wouldn't have existed in Arthur's time. However, we know from archaeological evidence that Bamburgh stands on the site of an earlier castle, which dates back to the sixth century, which lines up perfectly with the dates that historians claim King Arthur could have existed, so maybe, just maybe, Malory could have been right.

Location: NE47 6NW (Sewingshield Crag), NE47 6NN (Broomlee Lough), NE47 7JF (King's and Queen's Crag), the area of Walltown Gap (King Arthur's Well), NE69 7DF (Bamburgh Castle)

Walltown Gap, where is it believed there was once a well called King Arthur's Well.

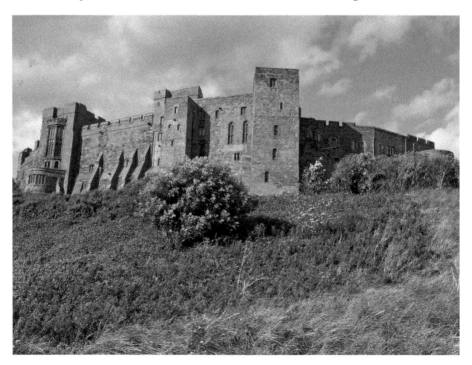

Bamburgh Castle.

The Beast of Bolam Lake

Bolam Lake Country Park, near Belsay, is famous for its wildlife, and in particular the birdlife, with mute swans seen on the 25-acre lake. However, it was a completely different type of wildlife that saw the country park hit the headlines in the national press in 2002 and capture the imagination of the nation.

Early that year, a party of fishermen was here fishing at dusk for the big pike that lurk within the lake, when they had a terrifying encounter coming face to face with what they later described as an 8-feet-tall creature covered from head to toe in thick dark hair, with glowing red eyes and huge sharp teeth. Needless to say, they were terrified and ran in fear for their lives. This report was initially treated as a light-hearted piece in the local media, with the creature being dubbed 'The Geordie Yeti'. However, in the coming weeks and months, the sightings became more frequent, often seen during daylight hours and every witness describing exactly the same thing. One eyewitness said that as the creature walked the ground shook. By now the Beast of Bolam Lake, as it was now known, was starting to gain a little bit of credibility and had became big news throughout Britain. The belief that this country park in Northumberland could really be home to a Bigfoot-like creature was gathering some support.

Jonathan Downes, professional 'Monster Hunter' and director of the Exeter-based Centre for Fortean Zoology (CFZ), believed the story to be credible enough to bring a team to the North East in January 2003 to spend five days and nights at Bolam Lake Country Park in the hope of seeing the Beast of Bolam Lake for themselves.

The CFZ interviewed a number of eyewitnesses, and it is noteworthy that one of the witnesses told the team that he had seen the creature on two separate occasions on earlier visits to the park, once in 1997 and then again in 2000.

On the first day of their investigation, all of their electrical equipment had power problems – fully charged mobile phones, laptops, and tape recorders all failed. However, this was nothing compared to what would follow.

On the following day at around 5 p.m. as dusk gathered, the thousands of rooks nesting in the trees were making a lot of noise when they suddenly fell silent. At the same time, something large was heard moving around in the undergrowth. Car headlights were quickly turned on and shone, full beam, in the direction of the noise. Eight people were present, and five of these, including Downes, saw a huge man-shaped creature run quickly right to left, vanish, then reappear and run back to where it had originally came from, left to right. After conducting experiments, it was estimated that the creature was 134 feet away from the onlookers at the time of the sighting.

Above and below: The woodland that surrounds the 25-acre lake.

At the end of the five-day investigation, Downes said 'The expedition was a success beyond our wildest dreams. The most exciting thing was that five people I interviewed had seen the beast at the same time - I was one of those people.'

He continued: 'What I saw was a dark, man-shaped object approximately 7.5 feet tall. It had a barrel chest and thick muscular arms and legs. I had a very clear sighting but I saw no glowing eyes and wasn't able to tell whether or not it was covered in hair.'

Over a year had passed since the night that the members of the CFZ witnessed the Beast of Bolam Lake, and after time to reflect, Downes wrote in his autobiography, *Monster Hunter*, about what he witnessed on that memorable night.

What I saw was an incredibly flat and angular figure, which appeared to be two-dimensional. It is here that I have greatest difficulty in describing my encounter because what I saw were so far out of the normal run of human experiences that there simply are not adequate words to describe it. I will do my best, but even now – over a year after the expedition was done and dusted – I still find it almost impossible to describe with any semblance of a coherent description.

As far as its shape is concerned, the nearest analogue that I have been able to come up with is the angular metallic running man which can be found in certain levels of the computer game Doom II. However, this 'thing' was matt-black. It was so black, in fact, that it was a quasi-human piece of nothingness, which had somehow become projected upon the Northumbrian landscape. It moved far too sharply and far too fast to be a living thing – at least in the ways that we know it. Again I have to resort to another unwieldy and fairly inadequate analogue. It was as if somebody had filmed this humanoid shaped piece of nothingness and then projected it back onto the landscape using the fast-forward facility on the video recorder. The whole experience lasted only a second, but it has been with me ever since.

In 1999, three years before the first reported Beast of Bolam Lake sighting, Theo Waitie was a young boy living in Hexham. He and his family were having a lovely day out in the sunshine at Bolam Lake Country Park when he experienced something completely unexpected, and it was so terrifying that it has stayed with him ever since. I spoke to him in 2007, and he told me of his frightening encounter.

It must have been late in the summer of 1999, and my mother, my soon to be step-father, my close friend James, and I, had all gone up to Bolam Lake Country Park for a picnic. When we got there my step-father noticed that the battery on his mobile phone was almost dead even though it had been fully charged. Strangely, my mother also had the same problem.

We went for a short walk through the surrounding woodlands and then went to a picnic area where we ate our sandwiches. After the picnic lunch, James and I went for a walk in the woodlands with my mother's cry of 'don't go too far' echoing in our ears. Inevitably, as all children that age, we strayed off the beaten track, onto the not so beaten track. Before long the not so beaten track became, well, forest. James and I weren't that scared really, it was the middle of the day and it was bright sunshine, the birds were singing, we were messing about, everything was great.

We walked a bit deeper into the woodland, and we became acutely aware of the birds having gone silent. We walked slowly and cautiously, and we were both a little on edge. I was thinking that the birds only would have stopped singing if something had frightened them. I said quietly to James "It would be worse if they flew away" and just at that moment the sky was filled with small birds, sparrows or tits, who had all flown out of five large trees.

Bolam Lake at dusk.

We walked very slowly, and the sound of our footsteps on the hard ground was the only sound. The hair on the back of my neck slowly rose up, and I could see that the hair on my arms and on James' arms had also gone up. Imperceptibly, there was a subtle change of light, and it seemed to go darker. We saw a shadow ahead, seemingly resting against a tree. I wouldn't be able to say an exact height, maybe, 7 feet high. The shadow seemed to be watching us and gave off a menacing presence. We both just thought it might have been some abnormally tall man, and I shouted to him, asking if he knew the way back.

When I said that, perhaps the light fell onto him better, or he craned forward slightly, but either way, light fell onto his head. It was not human. I don't think gorilla or ape would be the best word, but more like one of those pug dogs with the squashed in faces, stood on two legs covered in hair. The hair he had was very dark, black, and his eyes glared. You could feel his eyes as a physical force. We just slowly backed off, James and I watching the beast the whole time. We could hear it breathing, and it must have been breathing quite heavily as it was over 100 metres away. It was still against the tree, watching us. We turned tail and sprinted off as if our lives depended on it.

One of the locations where 'the Beast' was sighted in 2002.

Bolam Lake frozen over in the winter.

I ran away genuinely fearful for my life. We eventually found my parents but didn't tell them. To our horror, we had to walk with them around the woods. We were still petrified and shaking the whole time. We fed some mute swans at the lake to try and take our mind off things. Then as dusk started to draw in we headed back to the car much to my relief.

I have never been back to Bolam Lake since, and I do not wish to. One morning as I woke I heard a heavy sniffing outside my room, and it brought the terror I felt that day rushing back to me. James has now finished school and joined the Royal Air Force, where he is now studying to become a pilot, whereas I have stayed in school.

I am currently 17, and at Bolam, I was 9. An impressionable age, but there is no way even an impressionable child could have imagined this. We both saw the exact same thing.

Location: NE20 0HE

The Dwarves of Simonside Hills

The mysterious Simonside Hills lie within Northumberland National Park on the northernmost edge of Harwood Forest, the ridge overlooking the traditional market town of Rothbury below. Ancient cairns are to be found on the summit, and with a Bronze Age cemetery and a 2000-year-old Iron Age hill fort situated nearby, Simonside is a historical site of great importance.

The view from the top is breathtaking, offering a panoramic 360 degree view of the Cheviot Hills to the north, and the Northumbrian coastline to the east. The bleak, windswept wilderness attracts walkers all year round because of the beauty offered at every turn, with wildlife such as red squirrels and wild goats living within the forest at the base of the hills.

However, what many of those walkers don't know is just how much care they really should take when exploring the hills, for each step might prove to be their last, for legend tells of a race of dwarves who lead unsuspecting travellers to their doom in bogs, or off the edge of the cliffs.

The Simonside dwarfs have been called many other names in the 'news' stories and folk tales written about them: Bogles, Brownmen and, most commonly, Duergar. There are two schools of thoughts on the origins of this name: some believe it comes from the old Norse word for dwarfs (dvergar), and some believe that it is derived from the old Northumbrian dialect words deurgh, duerwe, dwerch, dorch, duerch, all meaning dwarf.

The ties to Norse mythology runs deeper. In a document from 1279, the Simonside Hills were called Simundessete, which is thought to have been taken from 'Sigmund's Seat'. Sigmund was from the *Volsunga Saga*, originally written in Icelandic (Old Norse) in the late thirteenth century by an unknown author. However, most of the material is based substantially on previous works dating back some hundreds of years. Sigmund was the father of Sigurd the Dragon Slayer in Beowolf, and J. R. R. Tolkien based Smaug, the dragon from his book *The Hobbit*, on this tale.

Some believe that J. R. R Tolkien, being from England, may have been aware of the legend of the Duergar, and based his Wicked Dwarves of the Iron Hills on them and the concept of a race of small people living, unseen, beneath the hills and mountains.

Bizarely, on the 1 December 2016, video game manufacturer THQ Nordic declared Rothbury the 'Dwarven Capital of the World', presenting Rothbury Parish Council with a certificate, recognising the Duergar and the influence this story has had on folk tales of a similar nature the world over.

Above and below: The bleak wilderness of Simonside Hills.

The Duergar have been described as being subterranean, coming out each evening as the final light of day disappears beyond the horizon, to prey on walkers braving the hills after dark, and then they disappear with the breaking of the dawn. They are noted for their strength and magical powers and have close ties to nature and the earth. The leader of the Duergar is said to be called Heslop (although some tales refer to a leader called Roarie).

The Duergar were written about twice in the local press in the 1889, with the *Newcastle Chronicle* describing them as a 'goblin race of beings', and the *Morpeth Gazette* wrote 'And once upon a time did not the caverns and recesses amid the rocky heights of Simonside nightly witness the unearthly revels of a tribe of ugly elves and dwarfs – so says tradition – amongst whom it was dangerous for the solitary wanderer to venture, and is not the dismal "Caudhole Moss," behind "Spy Law" – the home of Will o' the Wisp, who, in former years, led benighted and unwary travellers by his treacherous luring light into the depth of the bottomless heaf.'

One of the stories written about the Duergar is the tale of a sceptical man, who, having had enough of the tales of the dwarfs, went to Simonside with the sole purpose of proving that they didn't exist. He was warned not to venture on the Simonside Hills after dark, but his mind was made up and off he went.

He climbed to the top of the hills on a summer's night with a full moon and cried out for the dwarfs to make themselves known. Nothing happened. He cried out triumphantly 'see I knew yee didn't exist!' Suddenly he noticed a series of faint lights in the near distance slowly moving towards him, but the moonlight wasn't bright enough for him to make out the source. Convinced there was nothing supernatural to it, he walked towards the light. As he neared the lights he stopped when he saw each light was a lit torch held by a small man with a long beard. In their other hands, they each held a club. He turned on his heels, but before he could make his escape in the opposite direction he saw more lights behind him, and more angry dwarfs.

Before long the man was surrounded by the Simonside Dwarfs, each one glaring at him, but saying nothing. His fight or flight instinct to run had already been thwarted, so he charged one of the dwarfs, appearing to knock one over, but he noticed that he didn't appear to have hit anything solid; it was almost as if he had passed through the dwarf.

In a blink of his eye they all vanished. He looked around and there was no sign of them, no trace that they had ever been there. He questioned himself, and with one else there to validate what had happened, could he have simply imagined the whole thing. He turned around to leave, and the dwarfs were back, he looked behind him and he was once again surrounded, but this time there was twice as many of them. They had brought reinforcements. He fainted.

He awoke at first light, and there was no one else there. He headed home as quickly as he could, never again questioning the existence of the dwarfs, and never again daring to venture on the hills after dark.

The peaks of the hills can be seen for miles around.

The best-known legend of the Duergar was first documented in Frederick Grice's 1944 book *Folk-Tales of the North Country* and tells of a man travelling to Rothbury. The journey took longer than expected, and with night falling he finds himself on the moors at the bottom of Simonside Hills and is fortunate enough to happen upon a small hut. He was glad to find shelter for the night.

The hut had a fire, which was still alight (but going out), two huge grey stones and two gateposts. He was tired and cold, so sat atop of one of the stones and added some much-needed wood to the fire, which was soon roaring.

A little time passed, and then someone else entered the hut, a short man with a long beard, who stopped to look at him, and then climbed up on top of the other grey stone. The dwarf said nothing, so the traveller remained silent. The fire started to go out so the man threw some more wood on and the fire consumed it almost immediately.

The dwarf stared at the man and picked up one of the two gateposts, the one nearest him. He broke it over his knee in an incredible display of strength and threw both pieces onto the fire. The man knew the dwarf didn't appreciate his company, but he didn't want to go back out into the darkness, as he would surely get lost out in the darkness of the moors, so said nothing. Eventually, the dwarf spoke.

'Snap the gatepost and throw it on the fire' and gestured to the gatepost to the man's left. The man knew he couldn't do this so shook his head, trying to defuse the situation and anger the dwarf no further. 'Go on', the dwarf continued, 'just reach over and grab the gatepost'. Again the man said nothing.

Shortly afterwards the man fell into a deep sleep.

The heather in bloom.

He awoke at first light and was horrified by what he saw. He was still sat on the large grey stone, but he wasn't in a hut; he was sitting on the topmost stone on the top of a cliff. There was no dwarf, and there was no hut. He was sitting on the stone, and if he had reached over to reach the gatepost, as the dwarf had challenged him to do, he would have undoubtedly fallen off the cliff to his death below.

Location: Area around Simonside Hills

The Berwick Vampire

The historic border town of Berwick-upon-Tweed is the most northerly town in England, sitting 55 miles south of Edinburgh and 65 miles north of Newcastle-upon-Tyne. Few towns in Britain have experienced such a turbulent past. Between 1018 and 1482, Berwick was besieged on more occasions than any other town in the world with the exception of Jerusalem, changing hands thirteen times between England and Scotland. To this day, many Berwickers feel a close affinity to Scotland, and the 'Tweedside' accent spoken by the locals sounds far more Scottish than Northumbrian.

Architectural evidence of Berwick's eventful history remains today as a reminder of the town's occupants and visitors, including Berwick's magnificent town walls and ramparts completely surrounding the town, with four gates through which entry to the town is enabled.

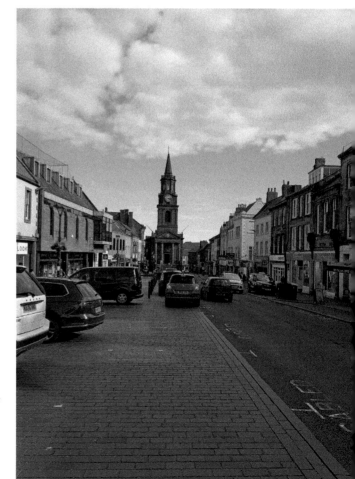

Marygate, the main street through Berwick, with the Town Hall visible at the end of the street.

Having such a bloody past, it's not surprising Berwick has tales of legend and intrigue galore, and it has one particularly incredible tale dating back to the early twentieth century. Berwick, much like Alnwick some 800 years earlier, had its very own vampire.

Colin McFaddon was a farmer living in Berwick and was besotted with his fiancé Betty Hough. They were very much in love and Colin saved every penny he earned so he could afford to make Betty his blushing bride. They met every weekend at a local public house. Their routine was always the same – they would have a drink and a sing song, and then upon leaving, they would head to the barn at Colin's farm to make love in the hay.

One fateful Friday night at the public house, Betty excused herself and headed outside to the outdoor netty, a primitive toilet consisting of a plank with a hole in it in a small wooden hut. Colin began to get worried when Betty had been away ten minutes. A couple of women came inside saying that they'd been waiting to use the toilet but the door was locked and the person inside wasn't answering when they had asked if everything was all right. Colin began to panic, heading outside and shoulder barging the door open. Betty was still sat on the plank, but she was dead. Her neck had been ripped open, and blood was still gushing from the wound.

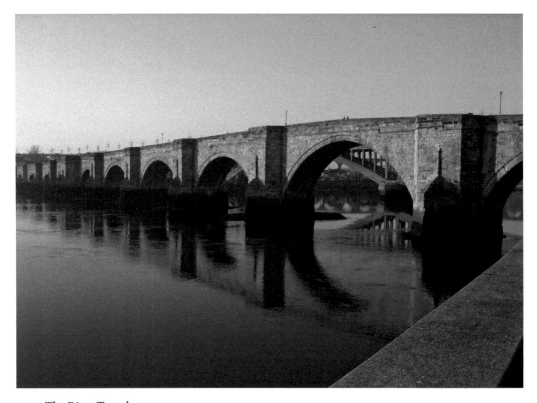

The River Tweed.

Word quickly spread of the horrific attack throughout the small community, many believing that there was a vampire in Berwick and it was only a matter of time before it took another life. Colin's world was destroyed. His one true love had been brutally murdered, and he couldn't shift the image of her lifeless body from his mind. He made a promise to himself to track down her killer and bring them to justice, no matter the cost.

Panic in the town grew further when farm animals were being mysteriously killed at night, bite marks being found and the animals seeming to have been drained of their blood. This strengthened the vampire theory and the majority of the locals who had scoffed at the mere suggestion were laughing no longer.

A few weeks later a sixteen-year-old girl was out picking brambles from a farm track. With the town fearful of another vampire attack, the girl's mother had told her to be home before it got dark. However, she completely lost track of time and dusk fell. She was concerned so walked quickly towards home, when she saw a dark figure up ahead walking towards her, a tall man of well over 6 feet dressed in dirty clothes. As they passed each other, the man turned around and jumped on the young girl. As she lay on her back with this man on top of her he opened his mouth to display two extremely large canine teeth, resembling

The Cumberland bastion.

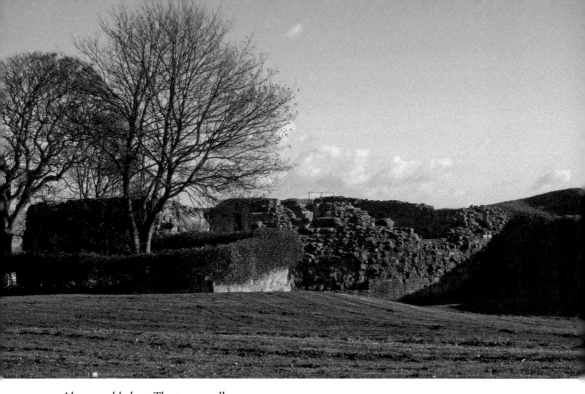

Above and below: The town walls.

fangs. He tried to bite her and grabbed at her as she screamed out. Two farmers heard the screams and rushed to the girl's aid. They wrestled the huge man to the ground and managed to restrain him. The man was taken to the magistrate, who said that the man was not a vampire, but he was a madman and would face trial for the attack on the young girl.

As he was being led away he bit one guard's throat out and made his escape as the other guards looked on in horror. Dogs were brought out to search for the fugitive and quickly picked up a scent. Colin had been told about this man resembling a vampire and was convinced that this was the killer of his beloved Betty. He rounded up some of the locals keen to rid Berwick of the vampire, and they joined the hunt.

The scent led into woodland and a small makeshift camp with the remnants of a fire and a number of small dead animals – dogs, cats and rabbits – appearing to be drained of their blood. Next to a huge tree was a large hole leading underground, which was where the man's scent ended. One of the men put their arms down the hole and felt a foot, recoiling in horror. Colin led the angry mob in for the kill. The dozen or so men quickly dug down and reached the deranged man. The guards were putting him under arrest but Colin had other ideas; this man had killed his wife-to-be, and he should not be allowed to live. Colin swung his shovel at the man with such force, it almost completely severed his head. Others started slashing out at the man, beating him to the ground before hacking away at him with their shovels until all that remained was blood and gore. A fire was lit and his remains thrown on, so that with the vampire destroyed completely, the town could return to normal and no longer live in fear.

Location: throughout the town

The Laidley Worm

The village of Bamburgh, on the Northumbrian coastline, is best known for its magnificent castle, arguably England's finest coastal castle, which stands 150 feet above the North Sea offering spectacular views for miles around. Visitors flock to the seaside village day in, day out, all year around, but especially during the summer months, to enjoy a day out in Bamburgh; to take in the historic castle, build sandcastles on the golden sands, and dine on fish and chips. In fact, a 2019 Which? consumer group survey named Bamburgh as England's best coastal destination. It truly is the perfect place in which spend a long, lazy summer's day.

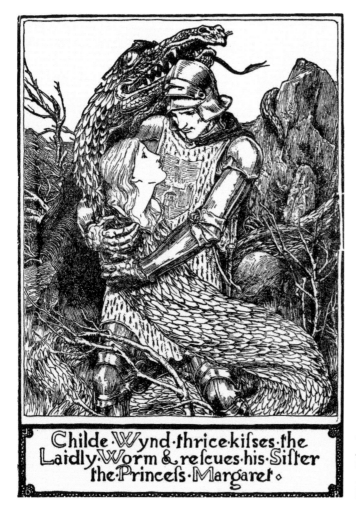

Childe·Wynd·thrice·kiſses·the Laidly·Worm & reſcues·his·Siſter the·Princeſs·Margaret.

An illustration by John D. Batten for the 1890 book *English Fairy Tales* by Joseph Jacobs.

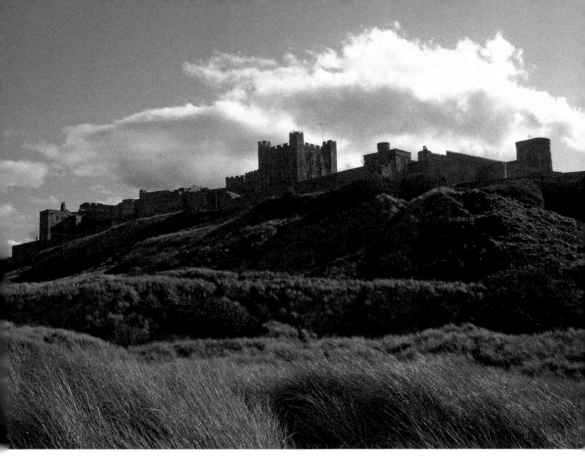

Bamburgh Castle.

However, legend has it that this wasn't always the case. Bamburgh Castle was once home to a king and queen and their two children, a daughter named Margaret, and a son named Childe Wynd. When he reached adulthood Prince Childe Wynd set off from Bamburgh to travel the world to seek his fortune. Sadly, soon after he set sail and left this family behind, his mother passed away.

The king mourned his wife, for he loved her dearly, but one day, while out on a hunt, he met a lady with whom he fell in love with at first sight. After a remarkably short courtship he asked her to be his new queen, which she accepted with glee.

Princess Margaret was understandably upset to hear of her father seeming to replace her mother, but she respected him as king, and knew it was not her place to question his actions.

The big day arrived, and the royal wedding was a huge event with well-wishers travelling from far and wide to try and catch a glimpse of the king and his new queen. As the wedding procession neared, the castle Princess Margaret was waiting to greet the new queen, her new mother. The queen, however, was immediately jealous at the princess' youthful good looks, and when she overheard voices in the crowd talking about the princess' beauty she decided there and then she was not going to stand for this.

Unfortunately for Princess Margaret, the new queen was secretly a witch, and after Margaret retired to bed that night, a spell was cast upon her:

> I weird ye to be a Laidley Worm,
> And borrowed shall ye never be,
> Until Childe Wynd, the King's own son
> Come to the Heugh and thrice kiss thee;
> Until the world comes to an end,
> Borrowed shall ye never be.

'Laidley' is a Northumbrian dialect word for 'loathly', meaning loathsome, and 'worm' being from the old English 'wyrm', which was a local word for a dragon.

When the princess' maidens came in to dress her in the morning, they were terrified to find her chamber destroyed by a terrifying dragon that had wrapped itself around the bed. The dragon moved towards them and they fled as quickly as their legs could carry them. The Laidley Worm escaped the castle and crawled for 7 miles until it reached the Heugh, or Spindlestone rock, upon which it coiled itself, breathing its terrible breath and fire into the air.

Word quickly spread, and before long the country knew the terror of the Laidley Worm of Spindlestone Heugh. The monster would spend day and night wrapped tightly around the heugh, but when hunger drove the beast from its lair it would kill and devour anything that it should come across.

Spindlestone Heugh.

A local sage was consulted who said that the worm was, in reality, the missing princess, and it is hunger that drives her to such measures. Every day the milk of seven cows should be taken to the trough at the foot of the heugh and she will trouble the area no longer. However, the spell must be broken, and the only way to do this is to get word to her brother. Childe Wynd must return, as he, and he alone, can save the princess.

Eventually news reached Childe Wynd, who was still overseas. He knew he must return immediately to rescue his sister, find out who was responsible and deal out a suitable punishment. His crew numbered thirty-three, and they headed home to Northumberland to save the princess. They sailed in a boat that Childe had had commissioned made from wood from the rowan tree, as having travelled the world he knew this had to be the work of a witch, and that rowan wood could repel evil magic.

They neared the Bamburgh shoreline that Childe Wynd knew so well. However, the queen sensed their return and used her magic to whip up a great storm, in which to batter the ship to ensure the ship was sunk long before it reached land. However, with the storm being borne of dark magic the rowan wood ensured no damage beset the vessel, and it continued towards Bamburgh.

The queen was furious and ordered the castle guards that should Childe Wynd approach the castle he was to be restrained until she could speak to him

The beach at Bamburgh.

and casting another spell she summoned the Laidley Worm with a command to destroy the ship.

The Laidley Worm appeared at the harbour, and as the ship came near, the Worm unfolded its coils, and, dipping into the sea, caught hold of her brother's ships and slammed it off the rocks. Three times Childe Wynd urged his brave men to row on, but each time the Laidley Worm kept it at bay.

Childe Wynd knew attempting to reach the shore at Bamburgh was useless, so ordered the ship to turn back. The queen thought he had given up the attempt, but he led the men along the coast, and they landed safely at Budle Bay. After touching down on dry land, he drew his sword, and followed by his men, raced to Bamburgh to cut down the Laidley Worm.

However, the moment her brother had reached his homeland once more, the queen's power over the Laidley Worm was broken, so when Childe Wynd confronted the terrifying beast, the Laidley Worm did not attack; instead, just as he was going to raise his sword, the voice of his own sister Margaret came from its mouth.

> O' quit thy sword, unbend thy brow,
> And give me kisses three;
> For though I am a poisonous worm,
> No hurt I'll do to thee.
> O' quit thy sword, unbend thy brow,
> And give me kisses three;
> If I'm not won here the sun goes down,
> Won shall I never be.

Budle Bay.

The Wynding Inn, just one of several placed in Bamburgh named 'Wynding' for Childe Wynd, with Bamburgh Castle in the background.

The Laidley Worm of Spindleston Heugh by Walter Crane (1881).

Childe Wynd sheathed his sword and kissed the Laidley Worm. However, nothing happened. He kissed it twice more, and the horrible Laidley Worm faded away, and before him stood his sister, the most beautiful maiden in the land.

She knew that it was her new mother, the queen, who had cursed her so, so they headed to the castle. They confronted her, and he touched her with a twig from a rowan tree. She screamed and turned into a huge ugly toad, with bold staring eyes and a horrible hiss. She croaked and she hissed and then hopped away down the castle steps never to be seen again.

The ballad of the Laidley Worm was first published in 1778 in a complication of folk songs. It was said to be have been originally written by an Duncan Fraiser in AD 1270 and transcribed by Revd Robert Lambe, Vicar of Norham. However, it is widely believed that Duncan Frasier never existed, and the tale was written solely by Lambe.

Location: NE69 7DF

The Hexham Heads

In the market town of Hexham, in the February of 1972 (although some accounts claim 1971), eleven-year-old Colin Robson was in the back garden of No. 3 Rede Avenue, the house he and his family had moved into only two weeks earlier. He was pulling out some weeds when he discovered something hard in the soil. As he moved away the earth, he found what appeared to be a tennis ball-sized rock. He took it from the ground, and rubbing away the dirt, he was surprised to find the rock had a face. What he was holding was a head made of stone. He shouted to his eight-year-old brother Leslie, who had been watching from an upstairs window, and he raced down to help. Shortly afterwards, he too had found a second stone head in the soil.

One head appeared to be male with short hair carved into his head and was called 'the boy', and the other was female with bulging eyes, a large hooked nose, even described by some who saw it as resembling a witch. This one was referred to as 'the girl'. Both were carved from grey stone with a greenish tinge, with flecks of quartz crystal. They had protrusions sticking out the bottom of the head at an angle, which it has been suggested could have been necks, and at one point they may have had bodies, or an alternative take is that these could have attached them to pedestals.

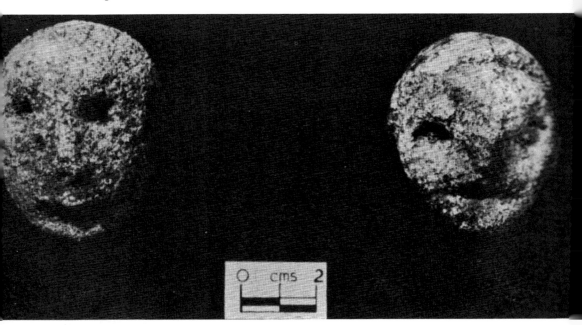

The Hexham Heads.

Above left and above right: The house where the Hexham Heads were found.

The boys showed the heads to their parents and various neighbours and then kept them inside the Robson home. However, shortly afterwards, bizarre events plagued the home. These occurrences were daily, with the most terrifying occurring between 2 a.m. and 3 a.m. The heads would always be found to have turned around, shards of broken glass were found in the bed of their two sisters, who moved out following this occurrence, and on another occasion a mirror was found to be broken, with missing pieces found in a frying pan. These supernatural

events weren't even confined to the Robson home; their neighbours, the Dodds, had an even scarier experience.

Ellen Dodd told a local newspaper at the time 'I had gone into the children's bedroom to sleep with one of them, who was feeling unwell, and my ten-year-old son Brian kept telling me that he felt something touching him. I told him not to be so silly.'

'Then I saw this shape. It came towards me and I definitely felt it touch me on the legs. Then, on all fours, it moved out of the room. I was absolutely terrified and screamed for my husband.'

She described the creature she had encountered as 'half human, half-sheeplike', and after leaving the room it had padded downstairs leaving the front door open. Her local council housing officers took her report so seriously they rehomed the family.

These happenings were too much for the Robsons. Before things could escalate any further, they got the stone heads out of the house, and an exorcism was performed at No. 3 Rede Avenue by the local church. The heads were handed to Hexham Abbey so they could be studied to identify what exactly they were, and why they appeared to be linked to supernatural occurrences.

The heads were studied extensively and found their way into the hands of Dr Anne Ross of Southampton University, who was a scholar and archaeologist with an expertise in Celtic artefacts. She believed the heads were around 1,800 years old, but wanted to conduct further research including excavating the garden at Rede Avenue, with the belief it could be a possible Celtic burial ground. However, before she could carry out her plans for further research, she too experienced the horrifying power of the Hexham heads. She described the chilling encounter, which occurred a couple of days after she took the heads into her home, in a television interview she gave to the *Nationwide* BBC television series.

I woke up in the middle of the night, we always keep the hall light on and the doors open, because our small son is a bit frightening of the dark, so there's always a certain amount of light coming into our room, and I woke up and felt extremely frightened. In fact, I was panic-stricken, and terribly, terribly cold. There was a sort of a dreadful atmosphere of icy coldness all around me, and something made me look towards the door, and as I looked, I saw this … thing … going out of it. It was about six feet high, slightly stooped, and it was black, against the white door, and it was half animal and half human. The upper part I would say was a wolf, and the lower part was human, and I would have again said it was covered with a kind of black, very dark, fur. It went out and I just saw it clearly and then it disappeared. Something compelled me to run after it. I got out of bed and I ran, and it could hear it going down the stairs and then it disappeared towards the back of the house. When I reached the bottom of the stairs, I was terrified.

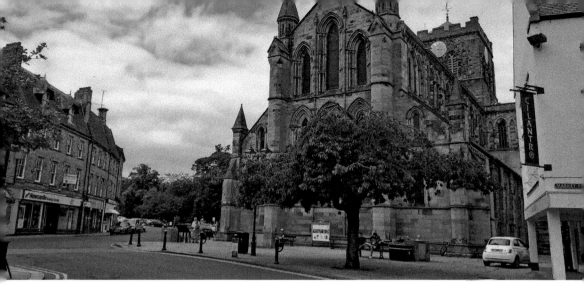

Above and right: Hexham Abbey, just one of many places the heads were taken to as studies were conducted on them.

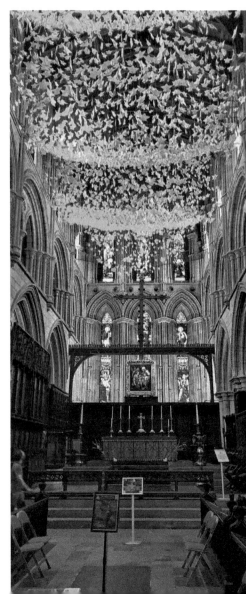

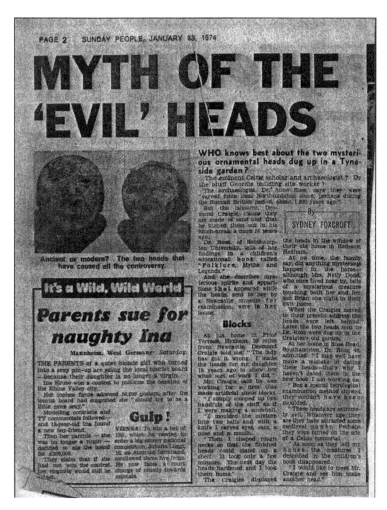

The Hexham Heads made national news.

A few days after I saw it, we had to go up to London for the day. Our fifteen-year-old daughter had come home from school about 4pm, and when we got back from London around 6pm, she came to meet us at the door, looking extremely pale and terribly shaken. She was reluctant to talk about it, but finally she told us what had happened. She had opened the front door, and as it swung open she saw a black 'thing' inside the house, which she described as near a werewolf as anything. It jumped over the banister and landed with a kind of plop, you know like heavy animal feet, and it rushed towards the back of the house, and against all of her better instincts, she felt compelled to follow it. It disappeared in the music room, right at the end of the corridor, and when she got there it had gone, and suddenly she was overcome by utter terror.

The day the heads were removed from the house everybody, including my husband, said it's as if a cloud had lifted, and since then there hasn't been a trace of it.

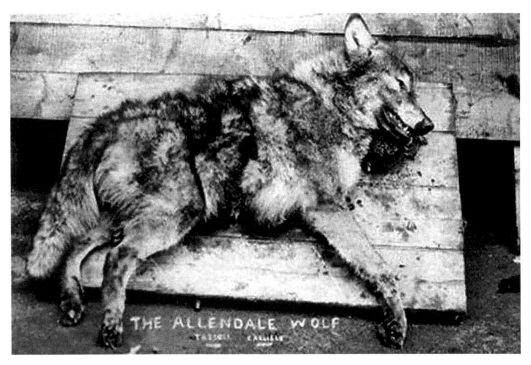

The Allendale Wolf who caused terror in Hexham in 1904 was brought back into the public consciousness following the 'wolf-like' encounters the Hexham Heads brought to those who took the heads into their home.

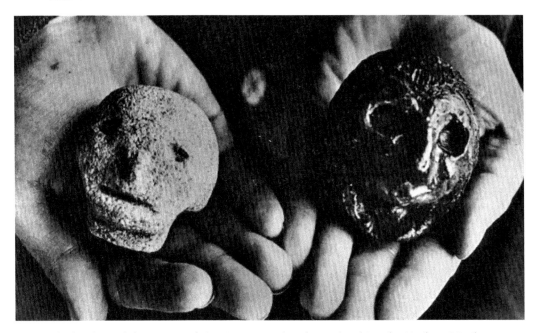

The heads made by Desmond Cragie to prove his claim of making the Hexham Heads.

The story took an unexpected twist when, after seeing the story in the press, a man called Desmond Craigie came forward and claimed that that the heads weren't 1,800 years old, they weren't even 180 years old, they were in fact 18 years old, and what's more, he made them. He explained that he had previously lived in the house, and in 1956, he made the heads to show his daughter what he does for a living. He went on to tell the Evening Chronicle newspaper 'I made the heads from bits of stone and mortar simple to amuse my daughter when she was a little girl. I actually made three, but one appears to have got lost. They were out in the garden for years. I definitely made them. I have been laughing my heads off about these heads, and I cannot understand why all this attention is being paid to them.'

He made some replicas to attempt to prove his claim, but these were analysed by Professor Dearman of the University of Newcastle, who concluded that the Craigie heads had been moulded artificially, rather than carved, as he had claimed.

As for the original Hexham Heads, media interest soon cooled, and long before, the 1970s were over they had simply disappeared, with their whereabouts a mystery today.

Location: NE46 1DB

Brown Man of the Muirs

The Brown Man of the Muirs (Moors) is a dwarf who takes his name from the brown clothing he wears, with striking ginger hair and a frightful temperament. According to legend, he lives in the moorland north-east of the village of Elsdon, where he is the guardian of all wild animals, dealing out punishment to anyone who dare hunt or harm the creatures under his protection.

Nineteenth-century folklorist William Henderson wrote in *Folklore of the Northern Counties of England and the Borders* of two men encountering the Brown Man while shooting grouse on the moorland. This tale was taken from a letter that the historian Robert Surtees of County Durham had sent to Sir Walter Scott in 1809:

> In the year before the great Rebellion, two young men from Newcastle were sporting on the High Moors above Elsdon, and, after pursuing their game several hours, sat down to dine in a green glen, near one of the mountain streams.
>
> After their repast, the younger lad ran to the brook for water; and after stooping to drink, was surprised, on lifting his head again, by the appearance of a brown dwarf, who stood on a crag covered with brackens across the burn. This extraordinary personage did not appear to be above half the stature of a common man; but was uncommonly stout and broad-built, having the

The moorland of the Northumberland National Park looking down on Elsdon.

appearance of vast strength; his dress was entirely brown, the colour of the brackens, and his head covered with frizzled red hair; his countenance was expressive of the most savage ferocity, and his eyes glared like a bull. It seems he addressed the young man: first threatening him with his vengeance for having trespassed on his demesnes, and asking him if he knew in whose presence he stood?

The youth replied that he supposed him to be the Lord of the Moors and that he had offended through ignorance and offered to bring him the game he had killed.

The dwarf was a little mollified by this submission; but remarked that nothing could be more offensive to him than such an offer; as he considered the wild animals as his subjects, and never failed to avenge their destruction. He condescended further to inform him, that he was, like himself, mortal, though of years far exceeding the lot of common humanity, and (what I should not have an idea of) that he hoped for salvation.

He never, he added, fed on anything that had life, but lived in the summer on whortle-berries, and in winter on nuts and applies, of which he had great store in the woods. Finally, he invited his new acquaintance to accompany him home, and partake his hospitality: an offer which the young man was on the point of accepting, and was just going to spring across the brook (which if he had done, says Elizabeth, the dwarf would certainly have torn him in pieces) when his foot was arrested by the voice of his companion, who thought he tarried long, and on looking around again, 'the wee Brown Man was fled'.

The story adds that he was imprudent enough to slight the admonition and to sport over the moors on his way homewards; but soon after his return, he fell into a lingering disorder and died within the year.

Sir Walter Scott wrote back to Surtees to say that the Brown Man sounds a lot like the Duergar of nearby Simonside Hills, suggesting there may be some connection between the two.

The origins of the name Elsdon, the domain of the Brown Man, are actually steeped in folkore itself, as its believed to be named for a Danish giant called Ella who terrorised the area in times long past.

Elsdon is probably best known for Winter's Gibbet, the macabre gibbet standing atop a hill, surrounded by rolling expanses of moorland, overlooking Harwood Forest below. It is a grisly monument to a murder that took place in 1791, when an elderly lady called Margaret Crozier was brutally killed by William Winter and sisters Jane and Eleanor Clark.

Margaret Crozier was a friendly old lady who sold cloth and other wares from her home to make a living, and one day was visited by Jane and Eleanor. The sisters couldn't help but noticed how many items she had around her home that they could easily sell for a decent sum if they were to steal them.

Above and below: The moorland is the domain of the Brown Man.

 The sisters had become friendly with a traveller by the name of William Winter who had recently arrived in Elsdon. Winter had been a criminal for all of his life, and when they told him of the old lady and all of her valuable belongings they could take from her, Winter saw it as easy money so took no convincing.

 The evening of 29 August 1791 saw a storm hit Northumberland, and Winter saw this as the perfect weather, as no one would be out on a night like this. The sisters hid nearby as William knocked on the door. Margaret answered and the drenched stranger at her door told her that he was a traveller who had got lost trying to find his lodgings and had got caught up in the storm. Kind-hearted Margaret immediately invited him inside, and with this Winter took his chance, brutally attacking her and killing her. He signalled to the sisters, who entered the home and the three of them stole anything of value they could lay their hands on.

Winter and the Clark sisters were so confident that the body wouldn't be found anytime soon, and even if it did there was nothing to tie them to the crime, that they decided to stay in the village, which proved to be their downfall. The trio were sat on a hillside eating fruit when an eleven-year-old shepherd called Robert Hindmarsh passed by. He noticed the unusual knife Winter used to peel his apple and instantly recognised it as belonging to the recently murdered and still undiscovered, Margaret Crozier. He alerted the police, and the three were quickly apprehended.

On 10 August 1792, the three of them were executed at the Westgate in Newcastle. The bodies of the Clark sisters were given to a local surgery to be dissected, but with feeling running high over this brutal murder of Margaret, it was agreed that William Winter's body should return to Elsdon and be hung in a gibbet cage for all to see. His body was taken on a cart and the gibbet was erected on Whiskershields Common, 3 miles south of Elsdon. His lifeless corpse was feasted upon by animals and insects, and eventually all that was left was his bones, which were scattered within 100 metres of the gibbet and the skull was sent to Mr Darnell in Newcastle. Who Mr Darnell was, and where the skull is now, is unknown.

Winter's Gibbet, as it now stands, isn't on the original site. This replica was erected in 1867 on the order of Sir Walter Trevelyan of Wallington. Originally, it was complete with a wooden body, but the body was removed as people started using it for target practise and now just a carved stone head hung here, but the head has been stolen on several occasions, and on the most recent occasion wasn't replaced. In 1998, the Entire Gibbet vanished. Thankfully, it was soon returned.

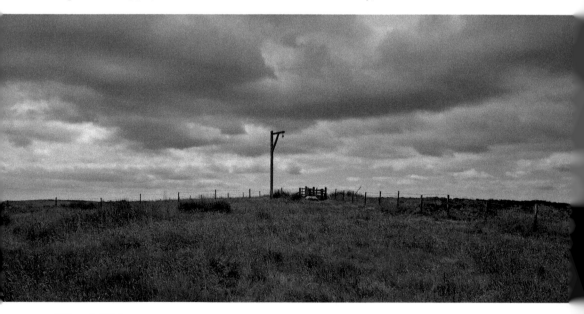

Winter's Gibbet.

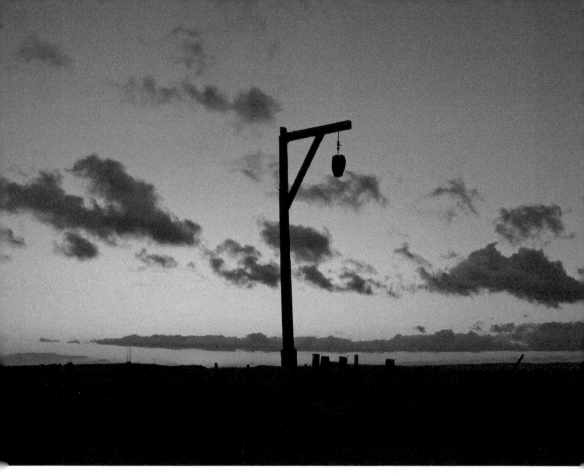

The stone head attached to Winter's Gibbet in 2007.

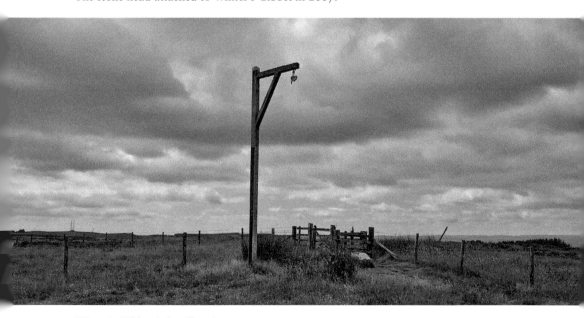

Winter's Gibbet is headless in 2021.

The ghost of William Winter is seen late at night at the site of the replica gibbet. This is most unusual as he didn't die here, nor was the original gibbet at this spot.

A local legend dating back to the early twentieth century is that a splinter of wood from Winter's Gibbet could be used to banish toothache. This has likely contributed to the gibbet having to be replaced a number of times.

Another folktale linked to Elsdon is the Hobthrush of Elsdon Moat (believed to have been Elsdon motte-and-bailey castle), who was a brownie, a helpful household sprit who would love to help around the house, the more menial the task the better. His only ask was that he receive no payment for his work. The Hobthrush that helped at Elsdon Moat spent his night working happily. Those he had helped wanted to show their appreciation so left him a brand new hat one evening, as it had been noted that the one he wore was very tatty. However, this gift was seen as payment by the Hobthrush and so he was never seen again.

Location: in and around the village of Elsdon

Above and below: Mote Hills in the village of Elsdon, the earthwork remains of a medieval motte-and-bailey castle

The Long Pack

Most versions of this tale are set at Lee Hall, an eighteenth-century manor house found just to the south of the village of Bellingham (pronounced Belling-jum) on the banks of the River North Tyne. However, a handful of versions set the scene as being Chipchase Castle. On a particularly stormy winter's day in 1723 a pedlar came to the hall seeking shelter. The lord and lady of the house were not at home so it was left to the three servants to inform the pedlar that their master would

Above and below: Lee Hall, now part of Hutchinson T. & Son farm.

not be keen on a stranger staying overnight when they were not present. The pedlar understood but begged that the servants allow him to leave a parcel there while he sought shelter elsewhere in the village. The parcel was incredibly long and heavy and would slow him down. They didn't see the harm in it, so agreed, and the pedlar would return the next day to collect it.

Early that evening, one of the servants, a young lady by the name of Alice, was in the kitchen when she heard a cough. This made her jump as she was the only person there. She picked up her candle and looked around assuming one of her fellow servants had joined her, however she was alone. The pedlar's long pack had been left in the corner of the kitchen, and at the very moment it entered the light offered by the candle, she saw the package move.

She silently but swiftly fetched the two other servants, and the eldest of the three, a man called Edward, loaded his gun (which some versions of the story say was called Copenhagen) and shot the long pack. The three servants jumped in horror as the pack cried out, and then was completely still, with blood pouring out of it.

When the pack was opened they found the body of a dead man, with a silver whistle around his neck. They quickly realised that this was merely a rouse to get the man inside the house, so he could unlock the door after dark, so the pedlar, and no doubt some additional accomplices, would come and help rob the house. It was already after dark now, so there was no time to lose. They sought help from across the village, and before long the house was protected by a small army of villagers, most armed with handguns and rifles.

The parish church of St Cuthbert.

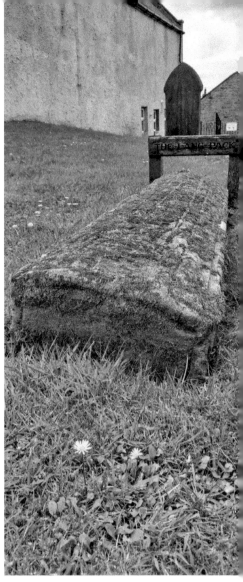

Right and below: The Lang Pack grave, 'lang' used to reflect the Northumbrian pronunciation of 'long'.

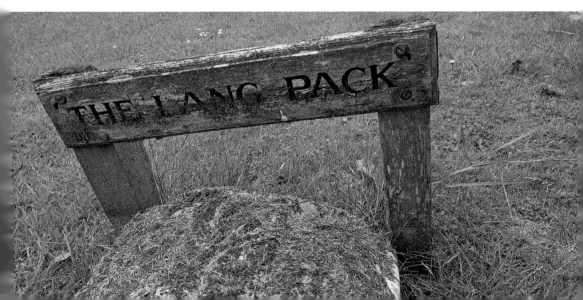

One of the villagers stepped outside into the night air and blew the silver whistle and then waited.

Before long the gang emerged on horseback in the grounds of the house, illuminated only by the moonlight. However, rather than being greeted by their fellow robber, they were confronted by the villagers who fired at them, killing four, before the remainder turned and rode for their lives.

It's not written what happened to the bodies of the four men who were killed in the foiled robbery, but the unknown body that had concealed themselves inside the long pack is buried at nearby parish church of St Cuthbert beneath a long stone to reflect the long package he had been inside and marked with the inscription 'The Lang Pack'.

Location: NE48 2JS

Northumbrian Faeries

Northumberland has countless stories, stretching back in time to the very earliest writings of the county, of faeries (or fairies), those tiny mythical winged beings from folktales the world over. There are stories of faeries all over the UK; however, Northumberland seems to have more than its fair share, but given the vast, remote areas of land, and the often troubled and forever mysterious history that the land has encountered, it is hardly surprising these faerie folk have decided to make Northumberland their home.

One such tale is to be found at Callaly Castle, in the village of Callaly, 10 miles west of Alnwick, although there are actually two Callaly Castles, and the cause of this is laid at the tiny feet of faeries.

The 'original' Callaly Castle hill fort.

Back in the twelfth century the Lord of Callaly decided to build a castle atop a hill, as it would offer clear views for miles around and be a better form of defence against the Scots, as relations with their neighbours to the north remained uneasy, and the English, especially those in the border region, were always at risk of Scottish raids. However, the Lady of Callaly wanted the castle down in the valley where it would be protected from the wind, and be a more comfortable family home. The lord's mind wasn't to be changed, so he began with construction of the castle.

Little did he know that he was actually building atop a faerie hill, and understandably, the faeries were not happy about plans to build upon their home, so every day, after nightfall, they would pull the walls down and scatter the stones far and wide. Each morning the lord couldn't understand what had happened, so after several days of this, he decided to hide on the hill one night to see who was dismantling his castle. When he saw the faeries taking apart his castle, he decided to go with his wife's preference and build the castle down in the valley instead.

There is an old Northumbrian rhyme which goes with the tale.

> Callaly Castle built on a height
> Up in a day, down in a night
> Build is down in the Shepherd's Shaw
> It will stand forever, and never fall.

And this is what came to pass, and as it says in the rhyme, the castle stands to this day, albeit converted into residential flats. Evidence of the original castle, despite the tale saying it was pulled down, can also be seen, an earthwork hill fort, at the top of a hill a little off the beaten path.

Ten miles north of Alnwick is Chathill, and on a farm here once stood a faerie ring. A faerie ring, also known as fairy circle, elf circle, pixie ring, or elf ring, is a naturally occurring ring or arc of mushrooms. They are found mainly in forested areas, but can appear in any grassy area. Faerie rings, despite appearing completely harmless, are linked to folklore and myth worldwide and are often seen as being tied to some of the darker aspects of faerie lore and that was the case in this instance for it was said that if any child should run around the ring more than nine times the faeries would take the offending child away, never to return. Legend says that despite children daring one another to circle the ring ten times, many would do it nine times, but none dared go around the tenth time for fear of being spirited away.

Another tale is to be found near Chillingham, a remote village best known for its thirteenth-century castle, which is one of the county's most imposing, and has found fame in recent years as one of the most haunted castles on the planet. Chillingham is also known for its herd of wild cattle, which have inhabited the 365-acre castle grounds for centuries. They are the only wild cattle in the

Callaly Castle has been converted into private apartments.

An example of a faerie ring.

world, sole survivors of herds that once roamed the forests of Britain, and are descendants of the British wild ox, which roamed the forested hills of northern Britain as early as the Bronze Age.

When Chillingham Castle's parkland estate was enclosed in 1220, a wandering herd of the wild cattle are said to have been trapped within the grounds, where they remain today, completely untamed, with no human interference whatsoever, and no vet has ever treated one.

Creamy white in colour with curved horns, the herd numbers around 100, with roughly a 50/50 split between cows and bulls, although cows also have horns. A king bull reigns over the herd and keeps his status (which usually lasts two to three years) when a younger bull challenges and defeats him, usually in a violent manner.

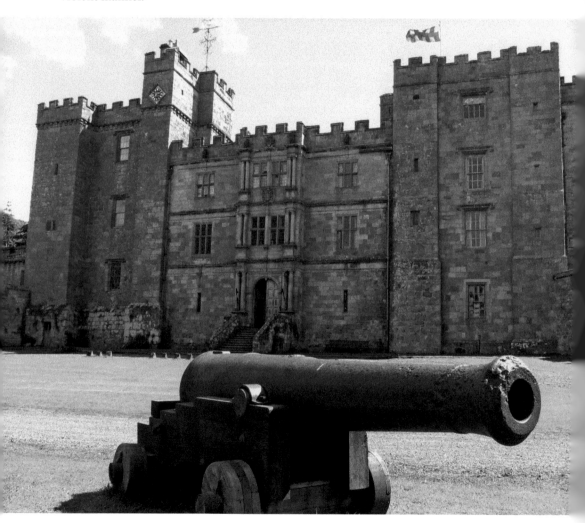

Chillingham Castle.

Chillingham's wild cattle.

Our faerie story here is linked to a 10-foot-tall stone dating back to between 1,000 and 1,500 years, at which point it was a carved stone cross. However, only the shaft remains, called the Hurl Stone, which stands atop a hill in a farmer's field near to Newtown. A lot of faerie legends revolve around ancient burial sites, or, as in this case, megalithic structures, the origin of which are lost to time, and what is often also unclear in these tales are whether the faeries reside at, or beneath, these sites, or if they are simply drawn to them, often to dance and sing.

Alnwick-born topographer, trademan and naturalist George Tate wrote in a magazine article in 1863, entitled 'Northumberland Legends', about a mysterious tunnel called Cateran Hole, which starts in the middle of a field, running directly beneath the Hurl Stone, but no one knows where it actually ends, although it is said to run underground for almost 16 miles all the way to Hen Hole in the Cheviots. The legend goes that a group of men from Berwick-upon-Tweed decided to explore the tunnel to see where it led. As they were passing along the narrow, dark passageway, illuminated only by candlelight, they stopped suddenly as they heard a sound. They heard the unmistakable sound of the music of a fairy harp, and the pattering of tiny feet dancing. Then they heard singing:

> Wind about and turn again
> And thrice around the Hurl Stane
> Round about and wind again
> And thrice around the Hurl Stane.

They never found out where the tunnel led, as they quickly turned tail and ran back the way they had came, never to venture into the tunnel again.

Left: The Hurl Stone.

Below: The Hurlestone Tower, standing next to the Hurl Stone, a lookout tower erected in 2000 to celebrate the new millennium, furnished for conferences and meetings.

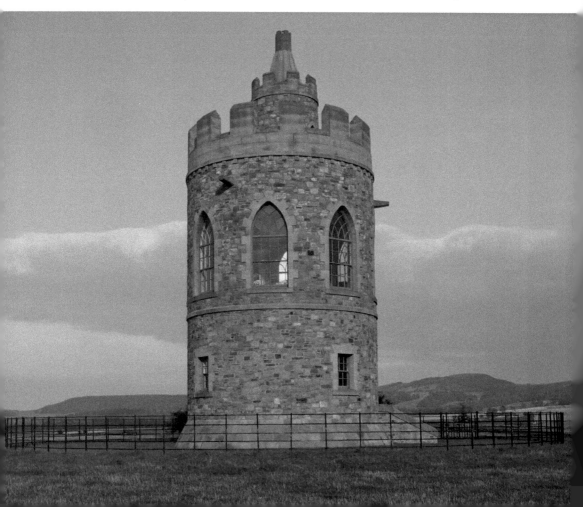

Cateran Hole.

Inside Cateran Hole.

The Hen Hole, which is occasionally called 'Hell Hole' in some older texts, referenced in George Tate's nineteenth-century tale, is a deep chasm on the north-west side of the Cheviot Hills, and it too has its own faeries. The faeries live deep within the hole, playing their enchanting music, and running and playing up in the hills, and down in the valleys. However, these faeries also have a dark side, and it has been written that there was once a party of hunters chasing a roe deer, and when they appeared to have lost track of their prey, the faeries told them it had gone into the Hen Hole. The hunting party headed inside and was never seen again. In the 1923 book *Northumberland,* Agnes Herbert added to this tale, claiming that if you should be at the entrance to the chasm at just the right moment, you will hear the horn of the lost hunters.

The Hen Hole has another legend, as it was the lair of a notorious outlaw in the folk ballad *Black Adam of Cheviot.* This tale tells how Black Adam, who lived in the Hen Hole, snuck uninvited into a wedding party at Wooperton, around 9 miles away. At the party, he discretely robbed guests of their jewels and valuables and then cornered the bride where he dragged her into a room where he ravished her and then stabbed her to death. The bridegroom, who had been away seeking the priest, returned to find his new bride dead. He heard a laugh outside the window and looked outside and saw Black Adam making his escape on horseback. Clutching his bride's bloodstained handkerchief, he immediately gave chase, pursuing Black Adam through the stormy night, across wild, rugged terrain until they eventually reached the Hen Hole. However, the bridegroom was not far behind and followed him into the cave where he confronted Black Adam. They fought and both of them tumbled to their deaths far below in the College Burn.

The Cheviot Hills.

The Three Sisters Waterfall running into the College Burn.

Cambo Fairy Hills.

Brinkburn Priory.

Agnes Herbert also wrote of the unusual signposts that are found throughout the village of Cambo, around 10 miles west of Morpeth. These signposts point towards the 'Elf Hills', and Herbert wrote 'The Elf-Hills near Cambo – that is, Cambo Hill, where Sir John de Cambo kept watch and ward – had, as permanent tenants, a gregarious band of "the little people" who did not in the least resent that their stronghold was often invaded and used again and again as a signal tower on which the wisp of tow mounted on a spear-point was set on fire when a raid was imminent.'

After looking at where faeries are said to live across Northumberland, our final location is Brinkburn Priory, where it is said that Northumberland faeries are buried upon their death. Despite being a legend that features heavily in texts of the county, little more is known about the faeries, and the actual burial spot is suspected to be a small hill just off the main car park. However, whether this definitely is the burial mound or not has been lost to time.

Location: NE66 4TA but closed to public access (Callaly Castle), found within Thrunton Wood ('original' Callaly Castle site); NE67 5DE (Chathill Farm), near to Newtown (Hurl Stone), north-west side of the Cheviots, a difficult 11-mile walk from the nearest car park (Hen Hole); throughout Cambo (Elf Hills); NE65 8AR (Brinkburn Priory).

Above and below: Brinkburn Faerie Burial Mound.

John Thirlwall's Gold Table

The lonely ruins of Thirlwall Castle stand close to Hadrian's Wall, on the banks of Tipalt Burn. The building was originally built as a large stone house in the twelfth century, and by the 1330s was in the ownership of John Thirlwall. The Thirlwalls were a wealthy family, so in order to protect their assets, as well as their family, John took stone from the nearby Roman fort of Carvoran and used this stone to fortify their home and turn it into a stronghold.

On 22 August 1485 Sir Percival Thirlwall of Thirlwall Castle was killed at the Battle of Bosworth whilst fighting in the Yorkist cause. He was Richard III's standard-bearer in the final charge at Bosworth. Legend has it that even when he had had his legs cut off in the battle, he continued to hold the standard of his king aloft until his dying breath.

Several generations of Thirlwalls survived the threat of Border raids during the Anglo-Scottish wars, and in 1542, the castle was reported in a survey as being in 'measurable good' condition, whilst in the ownership of Robert Thirlwall.

Following the Union of the Crown in 1603, times became more peaceful and the need to defend became almost non-existent. The Thirlwalls decided to start a new life 20 miles west in Hexham, where the soil was of a better quality and the climate was a little less harsh. Eleanor Thirlwall, the last of the family line, married Matthew Swinburne and sold the castle and its estate to the Earl of Carlisle for £4,000 in 1748. However, the earl was only interested in the land, so allowed the castle to become overgrown and decay until it became a derelict shell.

Over the centuries that followed the castle has been left to rot and crumble, with serious collapses of large sections of the castle walls in 1832 and 1892, the stone falling into the burn.

The future of the castle looked bleak, and it seemed likely that the castle would decay entirely. However, in 1999, the Northumberland National Park Authority took over management of the castle and have taken measures to preserve the ruin and make it safe for visitors. The conservation work was very carefully undertaken to preserve the nesting sites in the castle walls for the swifts, as well as the roost sites of bats.

Despite being one of Northumberland's lesser-known castles, Thirlwall Castle still has its own fascinating legend, which involves the man who turned that stone house into a fortified castle: John Thirlwall. John made most of his money in overseas wars, bringing back valuables including jewellery and gold. After one particularly far-flung war, John returned with a priceless table made of solid gold. As well as with the table he brought a hideous dwarf with dark skin, who was the table's guardian.

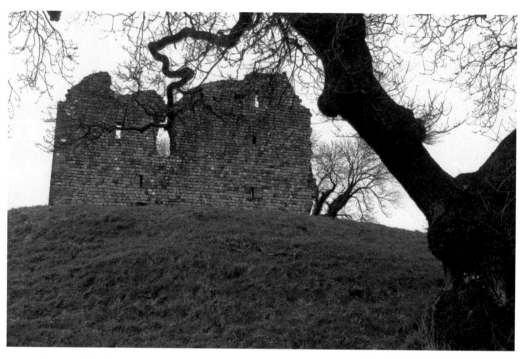

Above and below: Thirlwall Castle.

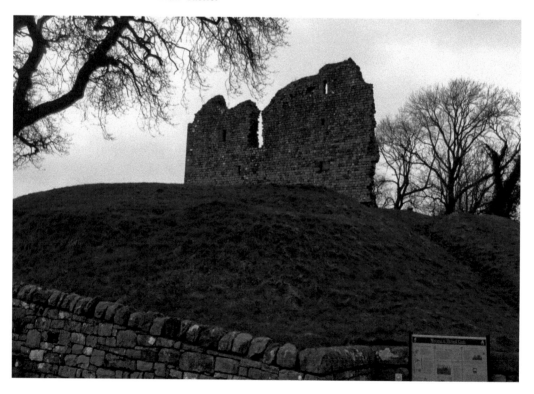

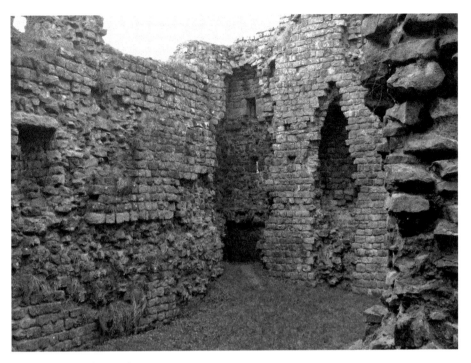

The interior of the castle.

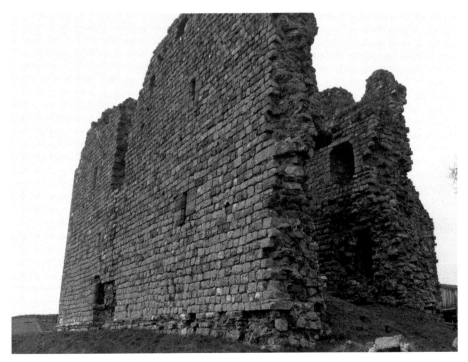

The castle has been empty since 1748, at which point it gradually fell into disrepair.

During one of many raids on the castle, Scottish invaders managed to get inside. The table was surely going to be seized, so the dwarf dragged the table to a well and dropped it down, leaping down after it. Legend says that even though the well has long since been lost to time, the dwarf remains there to this very day, underground, guarding the table. It is has been written that the dwarf will only allow possession of the table to be taken by the only son of a widow.

John Thirlwall knew nothing of the dwarf's plan to prevent the table being taken, and he assumed that the table was stolen by the Scots. The table was his most prized possession so to this very day the ghost of John Thirlwall can be seen walking throughout the ruined castle searching desperately for his table made of solid gold.

Location: CA8 7HY

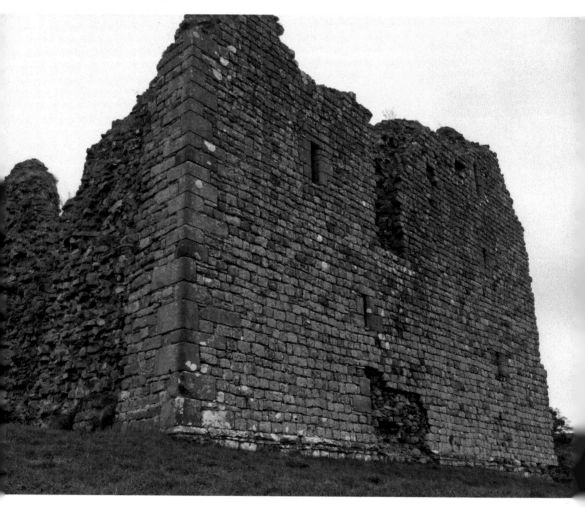

Could the table actually be beneath the remains of the castle, just waiting to be found?

Bibliography

Bord, Janet and Colin, *Modern Mysteries of Britain* (London: Guild Publishing, 1987)

Downes, Jonathan, *Monster Hunter* (Centre for Fortean Zoology, 2004)

Grice, Frederick, *Folk-Tales of the North Country* (Thomas Nelson & Sons, 1944)

Henderson, William, *Folklore of the Northern Counties of England and the Borders* (W. Satchell Peyton & Co., 1866)

Herbert, Anges, *Northumberland* (London: A. & C. Black Ltd, 1923)

Jacobs, Joseph, *English Fairy Tales* (David Nutt, 1890)

Jacobs, Joseph, *More English Fairy Tales* (Putnam Publishing Group, 1894)

Kristen, Clive, *Murder and Mystery Trails of Northumberland* (Casdec Ltd, 1993)

Lewis, Matthew, *Romantic Tales* (Longman, Hurst, Rees and Orme, 1808)

Malory, Thomas, *Le Morte d'Arthur* (William Caxton, 1485)

Percy, Bishop Thomas, *The Hermit of Warkworth* (York: Wilson and Spence, 1771)

About the Author

Rob Kirkup was born in Ashington, Northumberland, and has lived in the North East all of his life. He developed a keen interest in myths, legends, the paranormal, and all things considered supernatural or otherworldly from an early age, amassing a large collection of books and newspaper cuttings on the subject, and in particular tales based in his native North East of England.

Rob has been referred to as a paranormal historian, and his first book was published in 2008. He has since wrote a number of books focussing on different aspects of the history of Northumberland, Tyne and Wear, County Durham, Cumbria, York, and Edinburgh. In 2022 Rob started a weekly paranormal podcast called 'How Haunted?' which focusses on the history and hauntings of some of the most haunted places on planet earth . You can find 'How Haunted?' on your podcast app of choice. For more details, or to contact Rob, visit www.how-haunted.com.

The author.